THE ENDLESS
THREAD

THE ENDLESS
THREAD

Gerald Makin

BALBOA.
PRESS

A DIVISION OF HAY HOUSE

Balboa Press books may be ordered through booksellers or by contacting:

Balboa Press
A Division of Hay House
1663 Liberty Drive
Bloomington, IN 47403
www.balboapress.com.au
1-(877) 407-4847

ISBN: 978-1-4525-0838-2 (sc)
ISBN: 978-1-4525-0839-9 (e)

Balboa Press rev. date: 08/05/2013

CONTENTS

Acknowledgements .. ix

Introduction .. xiii

Chapter 1 .. 1

Chapter 2 .. 15

Chapter 3 .. 24

Chapter 4 .. 33

Chapter 5 .. 45

Chapter 6 .. 58

Chapter 7 .. 79

Chapter 8 .. 91

Chapter 9 .. 96

Postscript ... 103

The Endless Thread ... 105

Bibliography .. 107

To Muriel Amy Gifford
Fount of wisdom and knowledge

Acknowledgements

To my wife Jean, for many hours of typing and computer work, and
for her unending support.

To Dianne Kennedy for her meticulous editing.

To Ted Field for his literary knowledge, and his encouragement
when it was most needed.

To Scott Springer for his enthusiasm and material support.

To Trevor Sneath for all his expert technical help.

Do we walk in legends or on the green earth in the daylight?
A man may do both . . . The green earth say you?
That is a mighty matter of legend, though you tread it under the light of day.
 - J R R TOLKEIN

In my experience, the most difficult as well as the most ungrateful patients, apart from habitual liars, are the so-called intellectuals. With them, one hand never knows what the other is doing. They cultivate a 'compartment psychology'.

Anything can be settled by intellect that is not subject to the control of feeling-and yet the intellectual still suffers from a neurosis if feeling is undeveloped.
 - C G JUNG

Don't bother yourself with people who have all the answers, seek the company of people who are still trying to understand the questions.
 - BILLY CONNELLY

INTRODUCTION

I came here to take up a job I had applied for whilst still in England. If I had not done so I would have missed an extraordinary set of experiences. To say that I stumbled into them would not be quite true, yet it would be no nearer the truth to say that I sought them.

For whatever reason, I learnt things that in a remote past were widely known and accepted, but which were later driven underground by authority in the form of the Church and State.

Learning what I did was a very curious experience. It was as though I had always known these things in some part of my being, but had temporarily forgotten them.

Through long centuries certain keepers have transmitted these things in secret, and no written records were kept which could have been used against them. However they made records in visual symbols in a variety of art forms. These symbols have very precise meanings, and I was given the key to many of them. Part of what I present here us a detailed analysis of some of these.

The totality of what I am dealing with is too far ranging for me to attempt a complete picture, so I have tried to concentrate upon its most important aspects.

Scientific and technological development in the Twentieth Century increased at an unprecedented speed. It is hardly likely that this acceleration will slacken in the present century, unless some great disaster overtakes us. Part of the price we pay for this progress is that specialisations proliferate, until communication between them becomes extremely difficult.

This is a centrifugal situation. The world picture we have built up, our Weltanschauung, is almost totally deterministic and mechanical. Yet there are other ways of understanding and apprehending the world that are given scant attention. These do not deny technology or the scientific method, as science, officialdom and all establishments usually deny or ignore them.

Rather they enlarge the totality of truth and experience. In embracing both, with our critical faculties alive and active, we may arrive at a more balanced and complete understanding of ourselves and our situation.

In our culture we generally run away from the subjective, the intuitive, the aesthetic and the spiritual. Feeling is subjugated to what we regard as fact. Certainly there are situations where this must be so, but if we, or our present culture, continue to deny these aspects of ourselves and our world, we suppress much that is of vital importance to the realisation or our true nature.

This book is a journey into this other world as I, and other people I know or knew, experience it, together with material handed down to us by wise people from the past.

Tasmania 2012

CHAPTER 1

Changing views, the Leys and a meeting.

I look back trying to determine when I first encountered something not readily explainable in terms of our scientific and deterministic culture. It must have been when my wife and I were expecting our first child. We had bought an ancient car, all we could afford on my pathetically small teacher's pay. From our home in the English Midlands, we were driving to Pembrokeshire for a longed for week by the sea: it is hard to remember how much that meant in 1960.

Uncharacteristically, all through that westerly journey, through the borderlands and into Wales, my wife was gripping the dashboard, her knuckles white and she seemingly in a state of apprehension. We were approaching Hay-on-Wye, not then the second hand book capital of the world, but a grim, grey little town, where every day was the Sabbath. As we entered the thirty miles per hour zone, I saw a block of four cyclists ahead. I gently pressed the brake pedal and completely lost control of the car. In a terrifying moment we sliced down the side of an oncoming car and came to rest astraddle a hedge. Fortunately no one was hurt.

As the car's nose dipped slightly when I applied the brake, a built in hydraulic jack, which had come loose, caught the metal surround of a cat's eye reflector in the road, flinging us violently to the right.

My wife had known all the way down to Hay that there would be an accident, but what use would it have been to tell me? Owing to the generosity of a following motorist and his wife, we were taken on to our destination. On our way back we were able to pick up our car and slowly limp home.

If that had been an isolated incident I might have shrugged it off as my wife's pregnancy nerves, however out of character that would have been, but it was only the first of four, all connected with car travel.

By the time of the next one, I had taught at several grammar schools and was then lecturing at a teacher training college on the Essex coast . . . The village we lived in had not yet been discovered by commuters, although it was on a direct line to London, and all trains stopped there. Usually we made our visits to the capital by rail, but on one occasion I suggested going by car, to save money. My wife said it would be cheaper to go by train. I quoted the rail fare and the approximate cost of petrol, but could not convince her that we would save money. I became quite exasperated by her obduracy.

There had been no rain for six weeks, but as we approached Colchester, it began to pour. The road through Stratford in East London was paved with wooden blocks, originally intended to reduce noise from metal-rimmed wheels of horse drawn traffic. In rain they create a skid pan.

The Austin ahead of us, typically of that era, housed its rear lights in protruding fins. One amber light began to wink, indicating an intention to turn right. Once again I gently applied the brake, but we continued onward, poking out a headlamp on one of those fins. When the painful explanations and exchanges of address were over, my wife turned to me, 'I told you it would cost more.' I can't remember now what I felt like saying, but it probably was not polite.

There was little comedy in the next occurrence. Again, we were going on holiday, this time with our two children and pulling a caravan. Before we set out, my wife wrote down the registration number of our car and gave it to my father. She had never done that before. Upon our return, my father told us that the police had been searching Devon and Cornwall for us. My mother was in hospital, terminally ill with cancer.

Before leaving this there actually was an incident with an uncomfortable element of comedy. Our caravan had to live on the grass verge in front of our house. As this location could only be approached from one direction, parking entailed driving round the whole length of our crescent. We returned home in the early hours of the morning, but on our journey home, the Jaguar blew a hole in its muffler. Consequently an artillery barrage would scarcely have been more effective in waking up every inhabitant of the crescent!

The final car related incident happened some years after we came to live in Tasmania, that most beautiful island state of Australia. I was driving through suburban streets on my way home from work, seeing nothing but rain, until I crashed into the side of a car. Fortunately there was little damage and I was well insured, but my wife was waiting in the front porch for me. She knew that I had been involved in an accident.

The possibility of chance in such apparent foreknowledge decreases exponentially with each incident. My wife clearly demonstrated an ability I could not understand. My deterministic world suffered a severe dent.

Of later years there have been many examples of her curious abilities. I told my daughter-in-law that, if she were to stare at my wife's back, she would be aware of it. During a visit to Ireland, we were walking a little distance ahead of my son and his wife at Glendalough. Mary (we will call her that) decided to test my preposterous claim, so she stared at the back of my wife's neck. She nearly collapsed from an equal mixture of shock and amusement when, without turning around, her mother-in-law immediately placed two fingers in the small of her back.

We had been married long enough for both our children to have left home for some years, before my wife told me of an experience she had had at the age of nine, during the Second World War. Her home was destroyed by a German bomb, so she was sent to live with an aunt in a Worcestershire village. One Sunday morning, with a family party, she climbed Bredon Hill, to hear the bells ringing from the many churches in the vale below. A.E. Houseman immortalised this sound in his poem beginning, 'In summertime on Bredon, the bells they ring so clear.'

Standing on the height listening, and gazing over the countryside, this child saw straight, glowing lines, like the lights of neon signs, joining the hill to each church, and church to church, until lost in the haze of distance. At that age she saw nothing strange in this, believing that everyone could see the lines. She mentioned it to no one, until she told me. She had had a vision of the leys, as had Alfred Watkins, two decades before. Much more recently, looking down the Inglis River, at the little town of Wynyard, we knew that we were standing on a ley. It prompted me to ask my wife if she was aware of the width of leys. She said that they varied, that some were quite wide and told me that she thought as a child that the glowing lines she saw from Bredon Hill were roads.

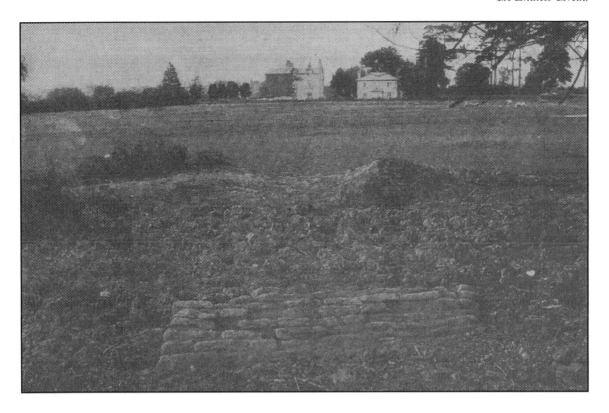

**Photograph by Alfred Watkins, sighted along a ley across Hereford Racecourse, toward Holmer Manor, the larger house on the left.
Our bedroom window is in the middle, partly surrounded by Virginia creeper.**

Watkins, a corn factor, was riding horseback over the Bredwardine Hills, in the neighbouring county of Hereford. Stopping to gaze over the familiar landscape, he saw glowing lines connecting many kinds of prehistoric sites, ancient mounds, standing stones and earthworks and leading to distant peaks. Following this vision he spent many years investigating these straight alignments in Herefordshire and elsewhere. His findings are described in his book, The Old Straight Track, for he believed these lines, or leys, to be prehistoric track ways. Along with many others, I cannot entirely agree, because of the difficult topography that many of the leys traverse, when there are much easier alternative routes. Certainly sections of the leys were used as tracks, but that seems not to have been the leys' only function, or even their primary purpose. In recent years, ley hunting has become something of a cult, with a consequent reaction seeking to debunk leys as pure imagination.

Although Alfred Watkins's lines joined prehistoric sites, and my wife saw lines going to churches, there is no contradiction. When Pope Gregory's missionaries were sent to Britain, they had instructions to build churches upon existing sites of worship. Since these were sited upon leys, it follows that so are many old churches in England.

Alfred Watkins was a respected and able businessman, a keen photographer and an inventor of photographic equipment. My wife is an intelligent and capable woman, who has held responsible and demanding positions in business and public service. She is no fey dreamer, yet she is very much aware of leys. If she walks, or even drives over a ley, she feels a tingling in the soles of her feet. Although she has always been aware of it, it is only in later years that she

has realised its significance. Later still she discovered that she is able to detect leys, ley points and other geodetically significant features by pointing with a straight left arm, with first and fourth fingers extended. When pointing along a ley or toward another significant feature, she feels a tingling in her left forearm. I have no such physical reaction to these things, but I am often able to 'see' them. I can't explain this, for there is no detectable mechanism or sensation, simply an awareness, a feeling of rightness and peace.

In The Old Straight Track there is a photograph showing a view along a ley across Hereford Racecourse. There are two large houses in the distance. The one to the left is, or was, for sadly it has been demolished, Holmer Manor. An upper window is on the course of the ley. When my wife and I had only been married a few weeks, that became our bedroom window. I wonder what influence that may have had upon us.

Although those car related incidents had forced me to recognise the possibility of prescience, it was not until I came, with my family, to Tasmania that I gradually began to escape from my rigid mental set. Three branches of the State Library are less than a half hours drive from home, and we have some good bookshops. Incidentally, it is a little known fact beyond our shores, that Australians read more books per capita that anyone else. That throw away line apart, I began to find myself reading about subjects I would previously have considered very dubious. Dowsing, UFOs and reincarnation were but three of them.

The first book I read at this time was about dowsing, or divining, for water. I had of course heard of this practice and was prepared to give it some credence, because it seemed to work in so many cases. People used forked sticks, angle rods and pendulums and they found water. There seemed to be no argument about it except where scientific tests were conducted. Then they didn't. Curious.

Another author included in his book an account of how he was able to locate, and accurately map, archaeological sites. Subsequent excavations apparently validated his predictions, to the chagrin of more conventional archaeologists.

When I was in my late teens and early twenties, I had a friend who believed in flying saucers. I thought him quite mad, at least in that respect. At the time when my views were changing, I knew three science teachers, three art teachers and a policeman, who were convinced that they had seen UFOs at least once. The car two of the art teachers were travelling in stopped and refused to move, until the UFO was out of sight. None of these people could be called naïve or in anyway dysfunctional, and all, in different ways, were trained to observe. Apart from these, many high school students told me of their sightings and there were interesting correspondences and cross references among them. Some may suppose that school children may make such claims from a variety of motives. In reply I say that through my long experience in dealing with young teenagers, I would know if they were trying to pull the wool over my eyes.

On top of all this, one evening, while my wife and I were watching television, my wife suddenly felt a compulsion to turn and look through the window behind us. She saw a bright red, clearly defined, cigar shaped object streak across the sky. Two ladies we knew also saw it.

We do not have, or we are not allowed to have, scientific proof of the existence of these strange visitors to our skies*, any more than there is any accepted scientific theory of water divining, yet I found it impossible to dismiss either of these phenomena out of hand. Rather, the more I read and heard about them, the more I became intrigued.

Then there was reincarnation, the idea that we, that is our spirits, return to Earth many times, inhabiting different bodies, usually viewed as steps in a process of spiritual development. I will lay this aside for the moment, because there is much to discuss later that will have a bearing upon it

When we had been in Tasmania a short time, we came to know a lady I will call Amy. I took her for a widowed countrywoman, retired to town. She dressed in an oddly old fashioned style. Her speech carried an accent I could not identify, though it seemed to suggest a rural background. She displayed great skill in lace making and crocheting, and supplemented her income with the sale of her work.

** That is now in doubt. It appears that much secret, though not quite so secret, work has been done with captured UFOs.*

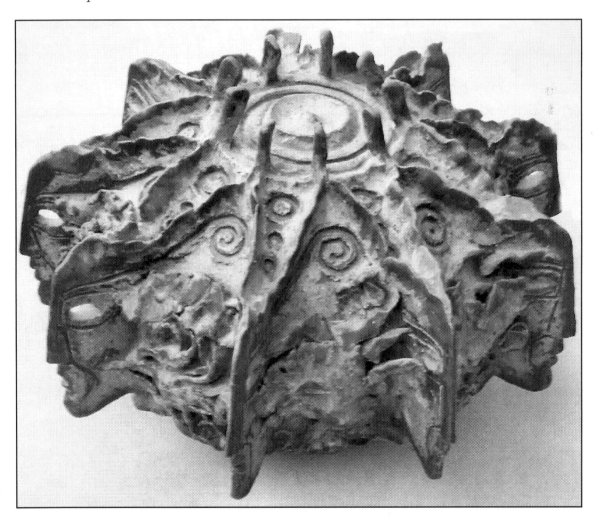

My ceramic sculpture symbolic of the Nine Guardians, in communication with each other through the standing stones, as they encompass the earth.

I had met Amy through our mutual membership of the Craft Association of Tasmania, but for some time she was just another member to me. Then one evening I had been asked if I would take her in my car to a neighbouring town, where I was to present a slide illustrated

5

talk. Afterwards, while I was putting away slides and projector, I heard the words, red, white and black rocks. Plato's words. his description of the rocks of Atlantis, which the Athenian Solon had obtained from the Egyptian priests. It was Amy's voice, and something told me that I had been intended to hear. On the way home I asked Amy where she had seen such rocks. "In the Azores," she replied. When I asked her why she had visited that mid Atlantic island group, in keeping with the old `bushy' image she chose to project, she said, "Going home, wasn't I?"

Sometimes I experience unaccountable intuitive flashes. I said to Amy, "You mean that you are of Cornish descent, and therefore Celtic, and that you believe that your ancestors came from Atlantis?"

"That's right," she replied.

Later I learned that Amy had been left a legacy by an aunt, with the condition that she spent it on travel. She visited every continent and various islands. One of her objects was to meet people in other lands who retained some part of the Atlantean tradition. When she visited India, she told me, the Dalai Lama was aware of her and sent an emissary to meet her. Amy claimed to be one of the Nine Guardians. As she refused to enlarge upon this I can only speculate about her meaning.

I drove up Amy's driveway to her cottage, tucked away at the rear of another house. I helped Amy from the car. She asked me to walk with her across her front lawn. As she was lame and always used a walking stick, I thought she needed my arm to lean upon. Not so, for she walked smartly to where a large aloe grew beneath her living room window. She drew aside its sword blade leaves. Shown in the light of the inverted southern moon was a standing stone. It was like an electric shock. Instantly I knew it to be a little brother to the ancient megaliths of Britain. I said, "It's the right shape, isn't it?" "Of course," she agreed. "You found the right place by dowsing," I continued. "I felt the pull," she said. I had absorbed all I could for one evening and wished her goodnight.

Sleep came slowly that night. Dream and reality seemed to have merged. Like Alice I had stepped through the looking glass, and the world could never again be the same.

During many subsequent talks with Amy, I learnt that she had been born near London, in a part of Essex, and that her family had gone there from Cornwall. She had been educated at a rather select girls school in London, which was attended by the daughters of foreign diplomats. There she discovered a talent for languages, several of which she spoke fluently. She also read Sanskrit.

In the Second World War, Amy served as a typist in the Air Ministry in London, but later as an agent parachuted into France, during the German occupation. There she posed as a half-witted assistant in a Paris bakery, where a German Luftwaffe major was billeted. She was able to monitor his communications concerning German air force movements and relay them back to London.

I remember her description of her parachute descent, with the sound of the 'plane dying in the distance, while the dawn song of birds grew louder as she neared the ground. Eventually she received warning that the Germans were becoming suspicious, and she was flown out by a Westland Lysander communications aircraft. After the war she was awarded the Legion of Honour by President de Gaulle.

Subsequently Amy trained as a nurse in Colchester, in order that she could employ her innate healing gifts without raising the ire of the medical profession. Eventually she and her husband emigrated to Tasmania, where she served as a district nurse in a rural area.

As a child and into her teens, Amy was taught an immense body of ancient Celtic belief and knowledge by her maternal grandmother. It was called simply The Words, and claimed to be far older than the Druids. I am sure Amy realised that I could not be convinced simply by being told this, and therefore she began to show me a little of the workings of her knowledge. In the past it would have been called magic, witchcraft or miracle. Amy denied that it was any of these. It was simply knowledge, ways of using natural forces, once known, but now forgotten by all but a very few, who have kept it alive through the ages. In the past church and state outlawed and suppressed it. Today science would scorn or simply ignore it. It had been passed on in secret, not only through fear of persecution, but because it would be dangerous in the wrong hands.

I must not give the impression that what I was shown was simply a series of party tricks. The things Amy demonstrated were done to convince me that I should listen and learn. What I learnt was that her tradition, as I shall call it, was at root profound spiritual knowledge, combined intimately with a form of science which operates on entirely different principles from our own, and also a moral code. That is a very inadequate description, but I hope to make some aspects of it clearer, as I analyse certain encodings of the tradition that have survived to our time.

Before proceeding further, I reproduce something Amy wrote for me. She gave it the title,

Carons, Na Garons. In the Cornish language this means The Permitted; the Forbidden.

Carons, Na Garons.

When we talk with Outlanders, there are things not to be discussed, and knowledge not to be revealed. How shall we know if some clever person leads us near to the Forbidden? There is a sign given to all of the true blood, when we are to be silent, the Old Ones will touch us and we shall feel a tingling shock like an electric current, it is quite unmistakeable and must not be disobeyed.

We are an ancient nation, we Celts, some call us the Trans-Alpine people; not so—The Words tell us that long ago we were sent East from Atlantis to the Danube valleys. (Others were sent West to the Amazon valleys—the Aztec peoples have this origin.) After a time we spread afar. Before the Sending, Wise Ones went over all the Earth, and they laid the ley lines, that none need be lost; and they set the power in the ordained places, that those who had need might find succour. The Words tell that for every generation of every family, there must be found one to listen, to learn, and to carry the Things that need to be known for the survival of all mankind.

We knew and revered the Power that created Earth and other worlds, long before the blessed Cristos was born. From the beginning we gave proper gifts to the Great Ones who rule things all around us. For Wind, Water, Sea, Stars, Trees, Rocks, Soil, and many other things, all have their Soul-

guardians—some good, some evil—and these must be respected or much trouble will ensue.

When we began to spread outwards from the Danube, we came over the Alps down into Italy, where we reigned in Rome for nearly 40 years at a time about 400 years before Christ. After we left, many of our people remained as settlers—witness the names we gave—Trevi, Treviso, river Trevia, and so on.

We went into Greece, spreading through Macedonia, Haemos, and Thessaly. Then by Thermopylae we crossed the high pass and came down through Parnassus to Delphi in 270, BC. Other Provinces we just passed through, but Thrace became and remained a Celtic kingdom until about 190, BC.

We went eastwards into Asia Minor, there we set up the model state of Galatia—those to whom S. Paul wrote his Epistle to the Galatians were our people.

Across what is now Rumania, down into what is now Turkey—there you will find names we gave—Avanos, Bodrum, Bolradin, Trebizand.

We set our feet in Cornwall, and traded and married with our cousins the Phoenicians and Cretans (they called our island home "the Cassiterides"—the Tin Islands.).

We were known along the African coast too, at Tripoli, Bardiyeh, Alessandra. Being the children of the sea, we also came to the Eastern lands—the Gulf of Aden, and across the Indian Ocean to Trevandrum, which was then a good port, to Ceylon even to China it is said, and also there is mentioned a land far south where the wind sings.

The Words tell of our going with the setting sun across our Mother Ocean to a place we now call the continent of America,—but then it was the Land of Red Leaves. (Could it be the maple trees?)

Even today you will find folks of our blood still wandering happily, because that is how we have always been—since before time we are wanderers, yet we love the land fiercely and must always go back to the birthplace.

I went back, and I've made my peace; set my feet on the ley and dipt mine hands in the calling-water;—kissed the rock and thrown bread on the tide; set honey for the Small Ones, and the prayer wreath in the place of the dying. So now the Spirits will bide along of me, and carry my soul to the other world ready to be born again when the time is right. For I do know this is neither the first nor the last earthly journey. It is a strange thing that so many people are afraid of the Dark Angel—I cannot understand why,—my people know it only a change, not an end, so therefore we should merely accept gratefully, and it is not proper to have fear of this which is really a blessing, in that it assures us all of another chance to do better next time.

There are things growing, and things to be found, also Words to be said, for to heal the body and spirit. There are places to be visited, and right and proper times to be receiving the Gifts from Mother Earth, and always a due to be paid for food, for health, for children, for setting the feet upon the bosom of the

Earth, and for sailing across Mother Ocean. For fair water most importantly, since all else is no use without this great gift.—rain it is that makes things to thrive, and folks to live. There be still waters to mirror the sky when the time is come not to look up. There be running waters to drink from for man and all other creatures. There be bubbling waters for magic and healing. There be waters of the Seas, for cleansing from sin and for healing foul ulcers and all manner of sores, and for the carrying of men as the Old Ones desire, to places appointed for them to see. For no man goes to any place except it be so ordered,—every life is guided. Many times we have to choose which of two courses we want to follow; and what becomes of us as a result of our choosing has already been decided,—before we choose. Many paths lead to the top of the mountain!

Those who are given The Gift at their birth, have the power to communicate without words across far distances, and to see into the future, and to know when the Dark Angel comes. Their hands are blessed, they can nurse the sick, feed the hungry, clothe the naked, deliver the new-born, comfort the dying. They have a great responsibility, to use their gifts wisely, and never for their own gain since that would bring down black vengeance upon them and their family.

It is because some left the Right Way and used great knowledge for greedy gains, instead of for good, that the High Place was washed clean by flood and hidden by earthquake. Only a few were left to re-seed humanity and to pass on The Words. Only the tops of mountains shew (sic) above water and soil,—and some places hid in jungle and desert remain of the Old Ones making. But of course the ley lines, the power, and the maps, are present forever. Though there be few who understand these things,—and many who scoff at our knowledge because secretly they fear us,—we pity them for they be poor ignorant fools in high places in government and learning. They lead their people the wrong way, and will not be able to save them from destruction—unless they open their ears and hearts, humble their pride, and accept the instruction that will give them time to change their ways, and repent of the evil they have done. For now they pay homage only to the evil one to Sathanoz and Até.

From this it is clear that reincarnation was a central tenet of Amy's beliefs, and a part of her experience. Amy told me about two past lives she could remember, and various books have been written about claimed remembered lives. Past life therapy is much in vogue, but I can't comment upon it, since I have been warned that I should not attempt to delve into this area. Only once have I had an experience that could be thought to be a past life memory.

I had enjoyed morning coffee in a popular cafe in town, and had decided to walk home in the bright, late autumn weather. My route took me over the river bridge, with views up the estuary to a range of high tree clad hills. Beyond the bridge I took a path through a riverside park and counted the kinds of birds I could see, in the water and on land. In part I kept to the paved way, at other times enjoying the sensation of springy turf beneath my feet. My conscious attention must have receded, for I appeared to be walking on a vast grassy plain, with a few small trees and low hills blue in the distance to my right and ahead. The sun was warm in a

cloudless sky, as it was in the world I seemed to have left. I was aware of companions walking with me, but I did not see them. In their company, and in the ambience of the place and the day, I was completely content, in a way I rarely am in normal consciousness.

How long this lasted I cannot say. Certainly not more than a few minutes, but I only became aware of it as a memory, when I was beyond the park and walking on a winding path between trees following the river bank.

Amy speaks of Atlantis, believing that her remote ancestors came from that land. I will not attempt to summarise the arguments for and against such a continent having existed. I will only say that Amy's knowledge and beliefs must have originated somewhere and, as I have indicated, I witnessed something of Amy's knowledge in action, but first I will say this. In Amy's Tradition, 'The Words", there is an account of the forming of Atlantis and Mu. According to this a large body hurtled towards Earth in a very remote era, impacting in the Indian Ocean, Pacific region. Shock waves travelled through the earth's core, and raised the ocean bed on the opposite side of the sphere, above the surface of the water to form a new continent in the Atlantic Ocean. Most of this body was absorbed into the earth, but a part of its surface remained above the sea level, forming another new continent, that of Mu. If Atlantis was indeed formed in this way, it cuts across the argument concerning the impossibility of such a land mass, based upon continental drift, and the near fit of the continents on either side of the Atlantic Ocean.

In the centre of Australia is the world's largest monolith, Uluru, formerly known as Ayers Rock. Most of its huge bulk is below ground level, though what is visible is enormously impressive and is regarded as sacred by Australian Aborigines. In The Words it is said that, when the body from space hit Earth, Uluru was a fragment thrown off.

On the upright piano in her living room, Amy had a small plant in a pot. Its little leaves grew on almost thread-like stems. I had given Amy a lidded stoneware pot I had made, the kind which might be used for sugar or honey, though there was no provision for a spoon in its lid. When I visited her on one occasion, she smiled and pointed to the plant. The pot stood to one side of it, and the plant's stems had wrapped themselves around it. I say that they wrapped themselves, because there seemed no way that such a delicate arrangement could have been made by human hand. The leaves nearest the pot were the largest, becoming progressively smaller with distance. Amy offered no explanation.

Next time I called upon her, Amy again drew my attention to the plant. Now the pot was in front of the plant and from each side the stems curled round it in an embrace. The plant had grown considerably and again the leaves were larger near the pot.

I asked Amy if I might look inside the pot. With her permission I lifted the lid, and saw inside a small stone, resembling a wizened potato. Some weeks earlier Amy had pointed out this stone to me, resting on her mantelpiece.

Having read about dowsing I had made myself a pendulum from a cotton reel and a short length of cotton thread. A gifted dowser I knew suggested that it would rotate in opposite directions above the positive and negative terminals of a battery. I tried this and found that indeed, when held over the positive terminal it rotated in a clockwise circle. Over the negative terminal the rotation was anti-clockwise. This man told me that it should answer my mentally asked questions with positive and negative answers in those same directions of rotation.

At this stage I was looking for logical explanations and could see no real connection between arbitrarily named positive and negative battery terminals and yes and no answers. I

did not realise that in such things metaphor could have a real significance. Added to this was my failure to obtain any consistent answers.

When I asked Amy what was so special about this stone that she had drawn my attention to it, she said, "You have a pendulum. Why don't you use it?"

Using a pendulum is like a game of twenty questions but without numerical limit. I began, and for once the answers had some kind of consistency. Amy's presence, I am sure, had more than a little to do with it. What I gathered was that a priest from Atlantis had brought the stone to Cornwall in 9631BC, just prior to the Sinking. To my amazement Amy beamed at me and said, "That's right," adding that its function was to heal sick plants and to enable plants to grow. I asked her why she had put it in the pot. "So that the energy won't make the piano go out of tune," she replied. When I questioned her about the energy, Amy said that periodically she had to place the stone in certain locations in her garden, leaving it over night to recharge. This energy she called the Life Force, and it is symbolised in her tradition by a green dragon.

After Amy died, I asked her daughters if I might have the little pot back as a memento, fearing that the stone within would simply be thrown away. Today the pot and the stone are in my house, but I am unable to use the stone. Perhaps one day I may receive instruction.

My next encounter with Amy's strange abilities occurred when we were discussing gardening. Once more we were sitting in the living room of her cottage, whilst outside the rain poured down. When I mentioned that I was going to buy some leek seeds, Amy said, "There are some little leek plants in my garden. Would you like some?" I replied that I would and thanked her, but said that we should leave them until another day when it would not be raining. "It will stop," she said, rising from her chair and walking towards her back door. She picked up some newspaper and her trowel and opened the door. There was no rain.

When Amy had wrapped the leek plants for me she pointed with her trowel to a plant with attractive foliage, by the step to her back porch. She asked me if I would like a piece of it. I said that I would, so she began to dig around the roots, but was unable to reach deep enough to free them. As she tugged it was obvious that something would break if she continued. She ceased pulling and said, "Come up." The plant simply came up with all its roots intact. But it was not yet free, because its stems had become entwined with those of a climbing plant, clinging to a wooden support of the porch. "Come free," Amy commanded. This time I saw a blur of movement, lasting perhaps half a second, and the plant was free. She wrapped it up and gave it to me together with the little leeks.

Naturally I was a little surprised by all this, although by then I believed Amy capable of almost anything. Recently I made the mistake of recounting this incident to a friend who has a PhD in science. "She must have hypnotised you," he said. The thing was patently impossible, ergo it did not happen. To believe otherwise would have violated his whole system of thought. In a rather lateral way I am reminded of the satirical scientific axiom I read somewhere: No new discovery should deviate from what is known to be true.

The mention of systems of thought reminds me of a lunchtime conversation with a colleague, when I was lecturing at a college for training teachers, before I came to Tasmania. He was an education lecturer and had written child psychology and education textbooks. I had always regarded him as a very pleasant and amiable man and a good conversationalist. However, as we were eating and talking, I began to feel that there was something a little strange in some of his ideas. All thought, he maintained, was verbal. I remonstrated that I did not verbalise all my actions before performing them. He insisted that I must do.

"If you are driving your car, and wish to turn left," I said, "do you say to yourself, I must press the lever to operate the indicator, then gently press the clutch and brake pedals, change down two gears, and turn the steering wheel anti-clockwise."

"Of course," he said," how else could I do it?" I looked at him in disbelief, but he was quite serious. He really was. A lecturer in child psychology!

Whilst respecting the opinions and fully recognising the achievements of so many scientists and academics, there is nonetheless a minority of experts who seem to be particularly expert in their own opinions. I recall once reading, and once hearing on radio, the statement that the ability to see colour, as we do today, did not exist in Homeric times, because of Homer's figure of speech, the wine dark sea. Who the original expert was, or who quoted whom, I do not know, but I do know that 'wine dark sea' does not mean wine coloured sea. It means just what it says. Red wine is dark, as can be the sea off Tasmania's shores.

Another expert, one on animal behaviour, on ABC Radio, stated that dogs can't see through glass! What wrong-headed experimentation led him to that conclusion? Light travels through glass to a dog's eyes as it does to mine. How could it not? Had he ever owned a dog? My dogs have seen me returning to them as they waited in the car, reacting at a distance in exactly the way a restrained dog does in the open. Yet the expert said that a dog couldn't see through glass. Preposterous.

Returning to Amy, there was an element of farce in another incident. The weather was warm and Amy's front door was open. I knocked and called her name. Amy's voice hailed me from the kitchen. She was sitting at her little table with her electric jug dismantled, struggling with the pieces.

Now I must explain the then Australian electric jug to anyone beyond these shores. It is simply a ceramic jug into which an element of thin coiled wire, wound around a porcelain core, is suspended. When the jug is filled the element wire directly heats the water. It only operates when the lid is closed. It is a perfectly safe and efficient way of heating water.

Amy lived very frugally on a pension. Instead of buying the complete element and core unit, she purchased only the coiled element wire, and was attempting to wind it around the core and fasten it to the bolts which would hold it. Instead of a screwdriver she was using an old scissors blade, and for tightening the nuts she had a rusty old pair of pipe grips. Not surprisingly she was having difficulty. My proffered assistance was refused. To many a resounding but harmless oath she persisted, until the final element end was around the bolt, with the nut poised above, ready to be screwed down for about fifteen millimetres. She did not touch the nut. Without any visible movement the nut was down and tight against the loop of element wire.

I knew that Amy's tradition forbade her using her knowledge for her own advantage, or that of her family. I said," You didn't oughter have done that, did you?" "Sometimes," she grinned," I can get away with it." She fitted the assembly into the jug and filled it at the tap.

"Now we'll have a cup of tea." She switched on and the jug began to sing—and then stopped.

I smiled what I hoped was a sardonic smile, as the air around Amy again turned blue with her curses. She had to reconcile herself to dismantling the whole contraption and tightening the nut in a more conventional way. At last we had our tea.

I could never make Amy admit or deny that it had all been intended as a demonstration to me.

Again it began to rain, when I was talking with Amy, drumming loudly on her roof. As I had arrived on my bicycle, I said that I would walk home; otherwise my trousers would be soaked. Although Amy was partially crippled and walked with a stick, she always insisted on accompanying me to the door on my departure, saying that if she did so, I would return. On this occasion, as she rose from her chair, the rain stopped, as though a switch had been thrown. "I think it will last until you are home." she said.

"Should I thank you?" I tentatively enquired. She replied, "No I don't think so."

Idly skimming through the morning's local paper, I saw a photograph of an elderly man looking down bemused at a pumpkin vine, spread out on the ground with forty moderate sized pumpkins attached. At that time I thought myself lucky if I succeeded in growing one. I carefully cut out the picture, and, on my next visit, showed it to Amy. "Come outside," she said. Leading me to the fence separating her garden from the neighbour's, she said, "Look over there." I saw the forty pumpkins on the ground, attached to their now withered vine.

There was nothing spectacular about Amy's garden, yet she always appeared to have a plentiful supply of vegetables, and good crops of fruit of many kinds. I often tried to persuade her to talk about the functions of her standing stone, but up to that point she would only admit that it increased the fertility of the ground. Since she would never draw attention to herself in anything connected with her knowledge, she had arranged a demonstration for me beyond the boundary of her property. Amy's neighbour could never have known how he managed to grow those forty pumpkins. I still have the photograph.

The last example of Amy's demonstration of her knowledge occurred when she had only a few months to live. For many years she had suffered from cancer, and had undergone a series of operations. In between these she had periods when she appeared to be in quite good health. She had many friends, each sharing some aspects of her many interests, art, crafts, music, literature and history among them. And she often helped people with personal troubles, giving advice, encouragement and when she deemed it appropriate, a forcefully expressed admonition. There was something about her that could make that a very chastening experience.

Amy was much more concerned with helping other people than dwelling upon her own problems, and, remembering many lives, she had no fear of death.

She had often spoken to me about a power in the ground that was there for the free use of mankind, which had been used in Atlantean times and later. Certain megalithic structures tapped into this power, the same grid of power used by 'the vehicles'. Early on in our talks I asked Amy if she knew how to employ this power. She assured me that she did, and indeed I had noticed that large rocks in her garden had their locations changed from time to time. Several times I asked her if she would demonstrate the use of the power, but she always refused. Shortly before she went into hospital for the last time, when her body was pathetically emaciated and she walked with difficulty, leaning over her stick, she finally relented.

"I will show you one thing," she said. "Come outside." She dragged herself onto the concrete path beside her lawn, to where some lengths of timber lay against her garage wall. Amy pointed to a six-foot length of hardwood, at least four by two inches in section. "Hand me the end of that," she said. I picked up the heavy length of eucalypt, using both hands. She gripped the end with the almost skeletal fingers of her right hand and simply waved the timber up and down several times, as though it were a reed. The strongest man could not have done that.

So what is this power? In all my questioning, the nearest I could get to an answer was that it had an electro-magnetic component, that it was anti-gravity in some cases, and that it had a spiritual dimension. Why this caution. If I knew its workings and wrote describing them, what would happen if unscrupulous people found themselves able to use this power?

These things I witnessed then, showed me a little of Amy's knowledge in action. I am certain that they were shown to me in order to convince me of the veracity of the things she taught. But why to me? I try to answer that question as honestly as I can, but it can be little more than speculation. I am a visual artist. As such, in some respects, I have to think logically, but I also have to work by intuition and to employ imagination. Therefore I am aware that the kind of sequential reasoning that determines so much of our thinking and doing, in our current complex society, is not the only mode of operating. Please do not mistake my meaning. Reason and logic (I use that word in the non-technical sense) are essential tools for so much of what we do, but they should not exclude feeling and intuition, those so called right brain functions. Naturally that raises the question of how we may be sure these essentially subjective things do not mislead us. There is no easy answer to that. All that can be said is that we have to test them over time and not to trust them with all our mental or material capital until we are sure of them. Perhaps then I qualified in that respect. I had feelings about things which, in embryonic form, resonated with what Amy was to teach me. It was as though I had always known them, but that they had been overlaid by strata of forgetfulness. Lethe.

My reading had loosened my grip upon my former deterministic beliefs. I had become much more mentally open and intuitive. That does not mean that I could no longer employ deductive reasoning, or that my hold upon normally perceived reality was in any way impaired, rather that I could now admit the existence of other aspects of reality. My own version of Plato's man-in-a-cave-seeing-only-shadows is to liken our situation to that of someone locked in a room from birth, with only one window to view the outside world. His reality is what he sees through it. Other aspects of reality exist beyond the other three walls, but he can never see them. We are in an analogous situation. Our number of senses is circumscribed, and our mental structure also imposes limits, therefore we cannot assume that what we perceive through our senses, however they may be amplified instrumentally, is the totality of the possible. Some people, such as my wife, see a little further into reality; such as Amy see vastly more. Because I acknowledged this, I could see things I was shown, without my world being turned upside down. They intrigued me but they did not worry or upset me. And so I was ready for what Amy had to teach me.

Amy had attended some of my exhibitions, where my work had been much influenced by the shapes of stones and pebbles I found on the beaches and riverbeds. When I asked Amy why she had singled me out to talk to about her knowledge, she said this. "I have seen your work in your exhibitions. Someone who has such an interest in stones is capable of being interested in something a little deeper." Such an enigmatic statement, I know, will be meaningless to many people. I well appreciate that. It is no detriment to them, for we all have our areas of interest and concern, but I understood what Amy meant, although I find it impossible to put it into words. Or almost so, for I had long been fascinated by the megalithic structures of prehistory in Britain and other places. Also I had instinctively recognised Amy's standing stone as something far beyond a piece of garden rockery, though I had no idea whence this recognition came.

CHAPTER 2

Guardian Spirits/Near Death Experiences/Spiritual Kinship of Mankind and Animals

The first time I visited Amy, gazing at the book lined walls of her living room and the multitude of plants in pots and hanging baskets, she said, "Do you think we are alone in this room?"

I cannot account for why I answered, "No." Perhaps feeling a little foolish, I added, "But who else is here?"

She pointed over her left shoulder and said, "Him." I asked who 'him' might be.

"He is my guardian, my angel," Amy replied. "He has been with me from my birth and through all my lives. He will always be with me."

Amy explained. Everyone has a guardian spirit who is with us from birth. Her tabby cat was curled up on her lap. I asked about him. "He too, he has his guardian spirit. All creatures have their guardians, though with the more lowly ones there is a spirit for a group". She told me that these spirits, or angels, had once been people like ourselves who, through many incarnations and further development elsewhere, had greatly advanced spiritually, and had now been charged with watching over the creatures of Earth.

On my many subsequent visits, with my constant questioning, which she bore with great fortitude, she would often pause before giving a reply, as though listening. Eventually she told me her guardian was telling her if it were right to answer my question, Carons or Na Garons, or she might be told the best answer for me. To my chagrin, many times her answer was, "I'm sorry, you are not ready for that yet."

So the world of the spirit was very real to Amy, as to a lesser degree, it was to become for me.

I began to find, that when I was in bookshops and libraries, certain books would, in some inexplicable way, seem to stand out, to draw my attention. Invariably I would find that they were important for answering my questions or extending my horizons. One such was the now famous little paperback, Life after Life, by Raymond Moody Jnr. M.D., which aroused a great deal of interest and controversy throughout the world.

Moody, a doctor and lecturer in medical philosophy, became aware that some hospital patients, who had been clinically dead and subsequently resuscitated, recounted vivid experiences during the period when their bodies exhibited no vital signs. In many cases their seat of consciousness seemed to be removed from their bodies and they found themselves looking down on them. Observing from up by the ceiling they viewed the resuscitation procedures. Later they were able to describe these accurately, recounting who was present and what was said and done. Some left the area and were able to give an account of things seen elsewhere in the hospital, where they had never been in physical form. Moody also collected accounts of near death experiences (N.D.E.s) from many other locations, and traumatic occurrences, road accidents, war casualties and others. Two medical people, a man and a woman, disbelieving Moody's findings and criticising his methods as unscientific determined to disprove what he had written by conducting their own research. To their initial dismay

they encountered identical information. It is greatly to their credit that they wrote a book supporting all that Moody had found, instead of denouncing him as a charlatan. Following this there has been a spate of books on the subject of near death experiences, and it has become an almost respectable subject of research.

Naturally there has been a reaction to the acceptance of NDEs. Some writers, usually connected with psychology or psychiatry, maintain that the phenomenon is an automatic function of the dying brain, that the visions of the pre-deceased relatives and beautiful places are a mechanism to calm the individual during the final crisis. There is however one great obstacle to this theory, the aforementioned accounts of people seeing and being able to describe accurately what was occurring around their bodies, when brain function had ceased. Evidently brain is not the same as mind, and consciousness may and does exist without it. For many this is too revolutionary a thought, but so once was the notion that the earth revolved round the sun.

As I was working in my studio one day, I tuned my radio to 3AR, the ABC's Melbourne channel. A programme began which was introduced as a study of death and dying. I confess that my first reaction was to turn it off. Then I thought that, as death is an inescapable experience, and since I believed in reincarnation, I should not shy away from it. The first part of the programme I found depressing, but later I listened to an account of a near death experience, typical of many, with the displacement of the centre of consciousness, awareness of being in a second body, being drawn through a tunnel toward a light and being welcomed by deceased relatives and friends.

Then a man was introduced who, many years previously, had been a student at Devonport High School in Tasmania. Since I knew, and had several times visited that school, my attention was immediately held. This man recalled that at the age of three he suffered from a heart condition as a result of having had scarlet fever. When he was fourteen, whilst at school, he suffered a heart attack and was taken to the sick room, the screened off end of a corridor. His pain was so severe that he wished to die. Suddenly the pain disappeared and he found himself looking down at his body. Discovering that he could move about at will, and that solid objects were no barrier, he went out through a closed window into the girls' playground and tennis courts.

Many people in the same state as him were present, moving about, seemingly busy about their own affairs, and taking no notice of him. Other students were also there, but his attempts to communicate with them made him realise that he was quite invisible and inaudible to them. He also saw one old lady spirit trying unsuccessfully to communicate with a schoolgirl. After himself conversing with this old lady, he returned to his body and re-entered it.

Lady teachers in attendance called the headmaster, who in turn, called a doctor. He arrived about half an hour later. In attempting to examine the boy, he caused him to exert himself a little and bring on a second attack. More intense pain followed and the wish to die, then again the wonderful peace, as he went out of his body. Many times he tried to communicate with the doctor and headmaster, to no avail.

Once more he went through the window and its protective grill, seeing many more spirit people, before coming back and re-entering his body. Then he was able to talk to the doctor, who diagnosed heart attacks and a rheumatic heart.

After the boy had been made comfortable and left alone, there came the most massive of the attacks, with indescribable pain in the chest and solar plexus area. If he had had the means

to kill himself he said, he would have done so. Once more the wonderful feeling of peace and love. Out through the glass and grill.

Wandering about, he eventually plucked up courage to ask a female spirit, who seemed robed in a material of gently luminescent ivory colour, what he should do. She directed him to go back to his body's resting place and, if he were really dead, people would be waiting for him, if not he should re-enter his body.

Two spirit people were waiting for him. One had been a teacher at Smithton (Tasmania) State School (a primary school) during the early 1940s. Later he joined the RAAF and was killed in a flying accident in Kenya, probably in 1941. This man introduced him to Lucas. He explained that Lucas had been a physician who had lived in Syria, and had been well travelled in that region, in Roman times. Lucas was left to his work of repairing the boy's heart.

Mr. W., the ex-teacher, wished to take the boy on a journey. On the way, while still in the school grounds of Devonport High School, they encountered groups of people. From time to time, a member of a group would break away, drift around aimlessly, and then rejoin the group. Mr. W. explained that they were suicided people, and the boy was told that they could not go on, because they had rejected the gift of life.

When Mr. W. left him he found himself descending a shaft. As he sped down, he attempted to touch the sides, but could not do so. Because he appeared to be descending, he thought he must be going to Hell.

He came out of the shaft into a very pleasant place, where there was a running stream and, across it on the right, he saw departed relatives, whom he wished to join. In the distance, to the right, there appeared a city with domes and spires. Then he noticed a lady, referred to in his family as Auntie, really an aunt of some of his cousins. She had been very religious. "Hooray," he rejoiced, "I'm not in Hell if she's here."

Now he found that he was surface bound, not able to fly, as earlier. He moved downstream towards a narrower section, so as to cross over. There was a boy coming towards him and they spoke together. This boy, E.W., was drowned at Smithton wharf, by riding his bicycle over the edge in December 1940 or February 1941. With him was another boy who had drowned from the Duck River bridge at Smithton, approximately two years previously. After his recovery, our high school student discovered that E.W. had a brother who was secretary of the Ulverstone Hospital. The drowning was established fact.

E.W. asked him what he was doing. He replied that he wanted to join the people on the other bank of the stream. E.W. said, "Well, I think you had better meet The Light first, so you had better come with us," indicating straight ahead. They moved along and joined a group of departed relatives, and he talked with them, particularly about religious and biblical matters. They were aghast, and gently chided him, when he said that religion was a fake and that we should do away with it. The boy's attitude was understandable because his current experience was so unlike anything he had been taught.

His attention was drawn to the approaching light. It was the brightest glowing light he had ever beheld; yet it did not dazzle him. A feeling of perfect love and peace radiated from the light, and he realised that it was a living being. He later commented, "In spiritual terms, the expression, GOD IS LOVE, is absolutely true, and an entirely adequate description."

There were various people present when The Light spoke to him, welcoming him and asking him questions, seemingly designed to put him at ease, questions about his family and where he came from. The boy believed The Light to be God and asked if he was about to judge

him. "No," said The Light, "we don't judge you. You judge yourself." There followed what he described as a playback of his life. Nothing was hidden and, because we can hide nothing from ourselves, he was the judge. However, in the pervading atmosphere of love, he did not feel too badly about it. The Light asked him questions about the state of the world and he answered as well as he could. Then he was asked what he had done about it. To this he asked what could he do about it, since he was only a fourteen year old schoolboy. He asked The Light where Jesus was. It appeared that Jesus was busy in the city at the time!

The two drowned boys and two of the men standing nearby took the boy into a building. In one part were people who had completed their stay in this place and were waiting to return to Earth, to be reborn by entering into babies, most probably at the time of birth. One disappeared, but soon returned, much to the amusement of the others. The baby had only lived a few minutes.

In a further part of the building the boy was taken to the Akashic Record. He remembered seeing what appeared to be many television screens, though he was not familiar with such things, as there was no television at that time in Australia. Only in later years did he recognise the similarity. In this place he was told that the whole history and knowledge of the earth was stored and was available to him. He was surprised to find how inaccurate was the history he had been taught. When he remarked upon this, he was told that it was because history was largely written by the conquerors. Also he learnt that the religion he had taken for granted as being true, was a distortion of the original form. Of course he was in something of a position to judge this for himself. He learnt more and more until he felt as though he had more knowledge in his mind than possessed by the sum total of mankind on Earth.

Somehow it had been determined that he had to go back. The boy was surprised to hear The Light ask if this was so, since he assumed The Light to be omniscient.

The boy said to The Light that he now knew that the religion he had been taught was all wrong, and that the only miracles performed by Jesus were those of healing, that the others were added in the early years of Christianity, along with other additions, which were intended to put more power into the hands of the priests. He said that he now knew that religion was not important. The Light corrected him, saying that religion was very important, but seemed to indicate that it did not matter so much which religion one adhered to.

Before coming out of the building housing the Akashic Record, he told his companions that he was going to use his knowledge to reform the world when he grew up. They laughed, and said that he could not take his new knowledge with him, because they would wipe it from his mind. He said they could not do that, and so they agreed on a test. They could attempt to wipe his mind clean, but afterwards he would tell them the Afghan word for red. Using some apparatus they took away his knowledge and he could no longer remember that word agreed upon for the test.

Lucas returned and told him that his heart was mended. There was some much more minor health trouble and the boy asked Lucas if he would cure that as well, but Lucas told him he would have to put up with it.

His return to his body was like stepping out of a bubble, back into the normal world. He looked back to wave to E.W., but all he could see was the red brick wall of the sick room. Regaining his body he thought of Abu Ben Adam, who awoke from a dream of peace.

Throughout his adult life to the time of the broadcast, and my subsequent meeting with him, this man's heart has been strong. He did have what is called a right bundle blockage,

which means that the electric signal to the right ventricle, triggering it to beat, could not be measured by current technology, but somehow it beats anyway.

After the boy's recovery, in his innocence he tried to confide his experience to his scoutmaster, but he would not listen. Next he attempted to confide in his church minister. The reverend gentleman simply told him not to indulge in morbid fantasies. Following this double rebuff from the very people he felt would have given him help and understanding, he kept it to himself until, after he had been married eighteen years, some incident prompted him to confide in his wife. That was thirty two years after the event.

In the curious way some things happen to me, my wife discovered that this man had been best man to the husband of a friend, and she obtained his name and address. Eventually we met. I presented him with a copy of my memories of his broadcast, which he kindly amended for me and supplied further details. These included the name of the teacher and RAAF pilot, E.W's full name and the name of the scoutmaster and minister. When I met him he was a professional man with a responsible job. I fully understood that he did not wish his position to be compromised by the revelation of his name.

He is a quiet, friendly man, with no fear of death. I can see no reason for his account to be either fabricated or elaborated. Either would seem to be totally out of character. Soon after we met, I introduced him to Amy and he visited her house, where I understand they had a lengthy discussion.

What are we to make of this account? It is certainly a very curious mixture of the fantastic and the ordinary. Ordinary in the sense that the world into which he was projected was peopled by seemingly ordinary human beings, at least some of whom were from his childhood locality. There were buildings and he saw a city. There was a stream, trees and apparently technical apparatus. It was a world which felt quite as real as our own, perhaps more so. In at least some cases, communication seems to have been directly mind-to-mind, or telepathic. Since he was with people from his own locality and background, no Chinese, Americans, Basques or Berbers, do we understand from this that our entry into this state between earth lives is eased through being tailored to our own familiarity?

There are similarities to many NDEs recorded elsewhere. The tunnel here is described as a descending shaft. There is a barrier, in this case a stream, which he did not cross. In some NDEs there is the knowledge that to cross the barrier means that return to the body is impossible. There is The Light and the life review and the absence of judgement other than his own. And there is that all pervading feeling of peace and love. Where this account differs from all the others I have read is in its length and richness of detail. Finally there are the checks he later made with relatives of the people he met in the other world. They were real people.

Looking at the note I had made while preparing an earlier manuscript, which this man read, I see that I had written, "I will not enter into a discussion of the Holy Trinity, or of their being co-equal aspects of God, which I think to be a nonsense invented by theologians." By the side of this he placed a tick and the comment, "How very true." Another comment he made was, "I have no fear of death, but events leading up to it could be most traumatic" Concerning suicides, he wrote," I understand that a relative or friend could help these people out of their predicament." Also, "Suicides are confused in life, and still confused in death."

In that manuscript I had also written: The boy took The Light to be God. Christians have frequently taken him to be Jesus; Muslims say that he is Mohammed. Did the Aztecs think that he was Quetzalcoatl? Is he one or many? Is he omniscient? He did not appear to know

that the boy had to go back. Amy says that The Light is the One, the Creator God. From the limitations of our understanding of time and space and of God (and of each of these we must confess that we know virtually nothing) we ask questions based upon our ignorance, such as, with all the thousands dying upon Earth in each second of time, to say nothing of those thousands or millions or billions of other worlds, how is it that The One, if he is indivisible, can spend the time to speak with each recently 'dead' human being?

To this he wrote, 'Different experiments in other worlds. Some more simple, some more complex than ours.' To the last question he wrote, 'Because we don't understand time'.

Again I had written: For me the most difficult aspect of the account of this other world was the apparent ordinariness of the environment. Surely Heaven, if this is what it was, is a glorious world of boredom where, if we are of the elect who reach it, we engage in the eternal flattery of a supreme being, who created us for the sole purpose of further inflating his perfect ego, from everlasting to everlasting, ad infinitum, ad nauseum. Hell would surely be more interesting.

To the first part of my rather laboured essay in irony, he commented, "No! People were active. Time is not the same. We cannot comprehend this."

To the last sentence, he wrote, "I don't think it (Hell) exists. In my Father's house there are many mansions. I do belief that Jesus said this." A further comment my friend made was, "Different but equally binding physical laws occur in the other dimension."

All this concerns the essential nature of our being and it seems appropriate here to add a little more.

It has long been held by many people that mind and brain are not synonymous, and what has just been discussed patently supports this view. Kirlian photography shows that the human body is surrounded by a field of energy, and the inference has been made that this forms a pattern, or energetic template for the physical body, as well as containing the true centre of consciousness. Not only is this true of man, but of all living entities. But by now the well known Kirlian photographs of incomplete leaves show the energy pattern completing the original undamaged form. People who have lost a limb frequently report sensations which seem to them to be in the severed member, although this is physically absent.

Psychically gifted people describe seeing an aura of light around people, which varies in colour and vitality from individual to individual. In sickness it appears dull, since sickness saps energy. Or is it that reduced energy is at the root of sickness? When an organ is not properly functioning, the aura exhibits a dimness or dullness of colour, frequently accentuated over the site of the dysfunction.

Research in the United States has shown that there is indeed a field of electro-magnetic energy encasing the human body and all living things. During an out of body (O.B.E), including that of near death, a large part of this energy field leaves the body, and consciousness is located within this departing entity.

Another comment was, "Perhaps everything is occurring at once and time is a myth."

From my reading, my many talks with Amy, and through my own speculation, none of this was really strange to me. All of my friend's account and comments concerning his O.B.E are entirely consistent with Amy's tradition. Belief in reincarnation is the corner stone. Schoppenhauer said, "Were an Asiatic to ask for the definition of Europe, I should be forced to answer him: 'It is that part of the world which is haunted by the incredible notion that man was created out of nothing, and that his present birth is his first entrance into life.'

Another cornerstone of Amy's tradition is belief in the Creator and the Gods. The latter are great beings, who are responsible for aspects of the Creator's universe. Amy's tradition says that, during the long height of the Atlantean civilisation, people left Atlantis to settle in other lands. This movement of peoples was called The First Sending. (The Second Sending was where some people were warned to flee Atlantis before the Sinking). One of the places they settled was the island of Crete. For a great length of time, and well after the Sinking, these people kept and guarded their knowledge of the Gods, deeming it unwise to share it with more primitive neighbours. When the peoples who became the Greeks, entered their region, some of them attempted to learn about these beliefs. To a very limited extent they succeeded, but they misunderstood a great deal. They learnt the names of some of the gods, including that of Pan, and that he had some connection with animals and trees. So it was that the familiar Greek figure of Pan came into mythology. The original Pan was, is, a very different being. According to The Words, in this close-kept Atlanto-Celtic tradition, the Lord Pan is the god whose area of concern is mankind, the animals and the trees.

Here I must explain that it was believed that there are many ladders of spiritual evolution. One ladder, to a degree, parallels the physical evolution of the animals and man. Another ladder is that of the plant kingdom with the trees at its head. However an important difference here is that the plant or nature spirits are exterior to the material body but, as in the case of animals and man, matter gives expression to spirit in this world.

Regarding animals, Amy taught that it is those animals which willingly dwell with man, cats, dogs, and one rung further down the ladder, horses, which are spiritually most evolved, and therefore nearer to us, rather than the anthropoid apes. I can well believe that. As an aside I would say that many people place dogs above cats, because they are more immediately amenable to the approaches and wishes of people, but that is a superficial view. Cats need to be closely watched in a loving and sympathetic environment to be properly understood and their potential realised. As is the case with people there is a vast range of understanding and competence with both dogs and cats. Some are plain stupid, some very bright, with the majority somewhere between.

Amy had a special relationship with animals. I saw an ant come under her door and approach her chair. She told it to go out again. It turned and went. Another day a butterfly was trapped between a window and Amy's net curtains. She said something to it and it alighted on her first finger, and allowed itself to be carried outside. A smaller ant came into Amy's living room. She complained that it should not be there, so I asked her why she did not tell it to go. "Oh," she said," "that sort is too stupid."

Two of our cats were run over outside our house, to our great distress. When we had Tuppence, as a kitten, we decided to keep him in at night, even when full grown. Once he was old enough to venture outside during the day, I asked Amy if she would tell him that he should not go into the road. My wife and I were strolling in the garden with Amy, when I handed Tuppence to her. She walked a little distance from us and appeared to be whispering in Tuppence's ear. I have never seen a cat look so surprised. It seemed obvious that Amy had communicated, so I asked her if Tuppence had promised not to cross the road. He had not, she said, but what he had replied was between him and herself. We kept Tuppence for thirteen happy years. He crossed the road. A neighbour asked, "Have you seen how your cat crosses the road? He sits at the kerb and looks both ways for traffic before he crosses."

In a Tibetan monastery a version of the New Testament, dated AD 353, was discovered some years ago. A most moving and beautiful incident is recorded in it:

'And Jesus came to a village and saw there was a cat which had no shelter. And Jesus took the cat in His arms and opened His robe, and the cat rested against His breast. And after He came into a house, He gave the animal food and drink, and the animal thanked Him. And Jesus gave the cat to a woman in His following who was a widow, and she took the animal and cared for it. And one of those that were with Him said "Behold! This man loveth all creatures. How is it that He loveth all living things as if they were His brothers and sisters?" And Jesus said "Verily, I say unto ye, these creatures are the children of God, even as ye are, and are indeed your brothers and sisters, and who so giveth them food and drink, giveth it to Me, and who so doeth them harm, and doth not protect them, harmeth Me, and doth not protect Me."'

What unspeakable things, during our Christian centuries, might have been avoided had this been included in our familiar Bibles. The churches still contend that animals have no souls.

I will resist the temptation to regale the reader with cat stories, and turn to spirits in relation to animals, and the contention that they, like us, are essentially spiritual beings. This was brought home to me in the following manner.

For some years we kept a small caravan on a site in the country, surrounded by hills and mountains, with a fast-flowing trout stream, coming down from limestone caves, forming its eastern boundary. We both had demanding jobs. On a Friday evening we would have a meal in town, relaxing as we watched reflections of coloured lights replace that of the sunset over the river. Then we would drive to our peaceful haven.

But one night was anything but peaceful for me. I was kept awake by a feeling of total disorientation, being quite unable to remember which way round I lay in relation to the landscape. Something to note here is that the caravan was situated on a ley. Here I must go back a little.

Ever since we had been in our present home, periodically my wife would wake me by calling out in the night. In a very distressed voice, sometimes sitting up, she would say that there were chickens in the corner of the bedroom nearest my head. I would gently reassure her that she had been dreaming, though she would insist that she had seen them.

To return to my disorientation in the caravan, I mentioned my puzzlingly bad night to Amy. "Have you thought about the direction your bed at home faces?" she asked. Although I could see no possible connection, by this time I knew better than to ask idle questions. So when I got home, I used the pendulum Amy had made for me, to ask if I should move our double bed. It indicated that I should. Reluctantly my wife agreed to try changing its position. This move placed her head in the corner where she 'saw' the hens. She had an awful night, with repeated visions of hens in the room. As soon as possible in the morning, I returned the bed to its original position, but I had some thinking to do.

I began to make some connections. We bought our house from a German couple. When we moved in, I lifted the hinged lid of a window seat in the kitchen. Inside was a copy of the Australian Woman's Weekly. On the chest of the cover girl, someone had drawn a Star of David in biro, with the legend, 'Juden Rauss', Jews Get out, beneath. I felt cold with shock to find such a thing in my new home, visions of Dachau and the other extermination camps racing through my mind.

Behind the house there is a wooden building, in which the original people who built the house lived during its construction. Since then it had been used as a laundry, with a copper boiler having once been installed, with an internal brick wall to waist height to protect the outer wooden shell. This building became my pottery studio. Needing bricks for the kiln I proposed to build, I began to dismantle the brick wall. Again I felt that chill when, behind the brickwork, I found the bones of many chickens. A few bones might have been children's mischief, but not this heap, representing the remains of perhaps six birds.

After I had replaced the bed in its original position, I used my pendulum to ask questions about the hens which so distressed my wife upon occasions. Was there a connection with the chicken bones? "Yes" came the answer. I then asked it if there were indeed hens in the bedroom. Again yes. Spirits of hens? Yes. Actually in the room? No. In the space below the wooden floor? Yes. Had they been confined there? Yes. Until they starved? Yes. I was horrified and saddened by this ghastly revelation. I went to the corner of our bedroom. In my mind I said, "Poor creatures, you should not linger here. You must go on to new life. Be free and go in peace." My pendulum indicated that they had gone. My wife had no further 'dreams' of chickens. Let no one, be he priest or scientist, tell you that animals have no souls.

"That man," Amy said, "had been in the SS, a prison camp guard." He had helped to starve people to death. Since he could no longer do that, he starved chickens. This was before his wife joined him in the house.

After I had sent on the spirits of those poor tortured creatures, I used my pendulum to ask if any more spirits of animals were in or beneath the house. Yes, came the answer. Room by room I went through the house. In the dining room I had a response near the wall overlooking the side garden. Asking what kind of animals were involved, I whittled the answers down to calves. Our house is built on gently sloping ground, so there is more space beneath the dining room than beneath our bedroom. A small door gives crawling access to this space. When we moved into the house, our son was eight years old, and used to crawl through the doorway. With another unpleasant thrill, I recalled his saying that there were bones under the house. So this deranged man had also starved calves. I sent their spirits on.

In the Judeo-Christian tradition, God gave man charge over all the creatures of the earth. This has been interpreted to mean that human beings have licence to do whatever they wish with any kind of animal. That is not so in the tradition I am describing. Here man is a custodian, an elder brother, and must treat animals as feeling creatures, never to hurt or harm without good cause. Certainly some may be a source of food; after all there are carnivorous animals, but we should never kill in cruel and stressful experiments. Those animals that would love us, we should love and care for most kindly. As my experiences demonstrated to me, animals, like us, are spirits for a time clothed with a body. They are what we have been. They and we are one.

CHAPTER 3

Stones, Stone Circles, Leys and Power

I have described my first encounter with Amy's standing stone and how it appeared to aid plant fertility, and also how she healed ailing plants with a stone. At the time I am writing about, although our garden was quite large, it would be an exaggeration to say that I was a really keen gardener. I liked gardens, but nobody accused me of having green fingers. Some plants lived, many died.

That grieved me, so I used my pendulum to ask if I would be permitted to place a small standing stone to aid fertility. My pendulum gave a Yes signal. I drew a sketch plan of the garden. Using a pencil as a pointer in conjunction with the pendulum, I found the stone's intended position against the eastern wall of my greenhouse. On site I again dowsed for the exact location, with such questions as, is it to my right? Is it directly in front of me? And so on.

More than a year previously my wife and I had taken a handsome, water rounded granite rock, about two feet long and very regular in shape, from the exposed bed of a river. The pendulum told me that this was the stone I should use, so I asked about its orientation and how deep it should be planted. A quarter of its height should be below ground and its major axis was to be north-south.

Once I had set the stone it looked comfortable and right. It fitted the environment in a way impossible to describe. During the next few days I found myself walking half way round the garden to reach my car, simply to look at it. It conveyed a feeling of peace.

At various times I had mentioned standing stones to Amy, hoping that she might encourage and help me to site one, in order to stimulate growth in my garden. She never gave any sign that this would be allowed, and always hinted that such things should not be meddled with. Having set my stone, with some trepidation I told Amy what I had done. She seemed surprised that the pendulum had indicated permission for this. Then she asked if it looked and felt right. When I said that it did she seemed content. She said that I should leave the stone for nine days then use my pendulum to ask if it was in the right position. Apparently it was.

A short while later I was talking to Amy, sitting in her living room with my back to the front or northern outside wall. The late afternoon sun was filtered pleasantly through her net curtains. I told her that the dowsing, seemingly telling me that all was right with the stone, had brought me a feeling of excitement, but also of great peace. She said that these feelings were not mutually exclusive. I was about to reply when I was aware of a vibration in my head, and remarked about it. I asked Amy where my chair was in relation to a north-south line running through her standing stone. My chair, she said, was on it. I remarked that it was not yet sunset, nor was it near the time of the new moon, which she had told me were the times when a vibration was most likely to be felt on the line.

Amy could also feel it. In a moment she said that a message was coming through, and that this was very strange, for it had never happened before when she had a visitor in the house. She rose to go outside. I asked if I should remain where I sat. "Come if you wish," said Amy quietly. I followed her out, taking a short cut over the side of her veranda onto her lawn, while she came carefully down the steps onto the concrete path.

As I watched, Amy approached the stone, to stand a short pace from it on the line to its northern side. She stooped and placed her left hand upon it, remaining still for perhaps a minute. Then she straightened a little, walking backwards along the line, as far as a little bush growing in the lawn, which she touched with the fingertips of her left hand. Turning round, she continued in the same direction to the edge of her lawn where, near the boundary fence, she took a sprig of diosma from a bush. This was done swiftly, without examining the sprig. She rolled the tiny pink flowers and feathery foliage between the palms of her hands, crushing them and releasing a pungent fragrance. Holding her hands to her face she inhaled deeply several times. Since touching the stone, Amy appeared like one in a trance, and I wondered at the content of the message. Once more she quickly plucked a sprig of diosma, a larger one. Then, returning to the stone, she carefully laid the sprig she had crushed against its base, with the ends of the little twigs to the west, in the direction of my home.

For the first time, Amy then spoke. "I am told that you must take this," she said, handing me the larger sprig. I replied, "I must place it against my stone in like manner?" "Yes. Note the three branches." I continued, "One represents your stone, one mine and one elsewhere." She nodded. "You must place it in front of your stone before the sun goes down. When it has turned brown you must burn it. I don't think you should ask any more now." However I did ask if it were permitted to weight the sprig down with a pebble, since my stone was in a more exposed position than hers. She told me that I could.

I drove the short distance home with the sprig lying on the front passenger seat. As soon as I arrived I looked for a suitable pebble. Bruising each flower to release its scent, I placed the sprig against the base of my stone, flowering tips to the right. A link had been forged, though I had little idea with what or whom.

Shortly after I had burnt the diosma sprig, my son came down from college. When I pointed out the stone to him, without offering any explanation, he held his left hand a few inches above the stone, then quickly took it away, saying that he felt a strong tingling at the junction of his palm and fingers. I pointed out to him that my pendulum indicated that a line extended westward from the stone, through and beyond the greenhouse. Unlike me at that time, he was able to dowse using a forked stick. He broke a thick fork from the nearby willow tree and held it above the stone. Going behind the greenhouse, his stick found the line. As he crossed it the stick bent backwards, pointing between his legs towards the stone. The pull was so strong it snapped. With another forked twig he found the line extending eastward, and I realised that it must be heading towards Amy's stone.

Amy was away from home at that time. When she returned, my son and I paid her a visit and asked her permission to dowse to the west of her stone. The line was there. Our stones were connected.

When I next visited Amy, she had been unwell and was still confined to bed. Her bed faced north and she could see through the window. As I was talking to her, she pointed and asked me if I had noticed the birds. I looked and saw several young blackbirds flying past. Amy said that they were flying up and down the line between our stones. When I asked her why they were doing this, she answered, "Telling you that you are wanted at home." A moment later the telephone rang. It was my wife telling me that a lady, who wished to buy some pottery, would be arriving in a few minutes, two hours earlier than arranged.

I asked Amy how birds could know such a thing, but she only reiterated something she had already told me several times, that birds and animals, even insects, know far more than we give them credit for.

Going back in time, long before setting my stone, I had met a distinguished Australian author, who was interested in talking with Amy. My wife and I invited him, together with his wife and Amy, to lunch. It is too long ago for me to remember much of the conversation. Amy was very good at talking in generalities, while being careful not to say too much about her knowledge. What I clearly remember is how she took us all out into the garden and demonstrated how she could detect some kind of force on the ground. This she did by extending the first and fourth fingers of her left hand, whilst making a pyramid of the remaining fingers and thumb, feeling a pain in her shoulder when her fingers pointed to the force.

My wife, alone among the rest of us, found that she shared this ability, but the author found he could detect the force using a forked willow stick. Following Amy, both could detect three widely spaced spirals in the ground. Strangely these spirals disappeared when my stone was set.

I hoped that my garden would improve once my stone was in position and activated. This was not to be. Using my pendulum, I asked, should I set another stone? No, was the response. Only after six months had elapsed, the reply changed to yes.

When the second stone was set, I soon found that I had to set another, then another, until there were many standing stones of varying size and form around my garden. All looked comfortable and right, and curiously none of them seemed to get in the way of normal gardening activities.

My gardening efforts bore little better fruit, but I found that detectable lines were formed, connecting each of my stones to each other in a kind of web. Another thing I found was that either a spiral line, with the first stone at its centre, or a series of concentric circles, filled the whole garden. Because of many obstructions to tracing the line or lines, it was impossible to determine which it was. I have good reason to believe it is a spiral, and that the three former spirals had been subsumed into this far larger one.

In a copy of 'The New Scientist' I found an article describing how a woman dowser traced a spiral within the Rollright stone circle in England. Subsequently a physicist, using a magnetometer, traced the same formation. Much more recently, whilst visiting Britain, I too was able to find it, using a rod.

There is another reason why I believe that what I, and others, detect in my garden is a spiral. Amy spoke of a grid of points of power covering the whole Earth,—'and they set the power in the ordained places.' She said that the power from these points was used for many purposes in ancient times. As is the case with the leys, these points have been rediscovered in our times.

A New Zealand airline pilot, Bruce Cathie, wrote a book, Harmonic 33, in which he described how he and other pilots saw UFOs hovering over certain locations in New Zealand. On a hunch he plotted these on a map and found that they formed a regular grid, with intervals of three nautical miles. He extended this grid mathematically over the entire surface of the earth. His belief that UFOs draw power from these points is identical with that in Amy's tradition. Amy told me that my original standing stone marks such a spot. Although I have seen no UFOs above my stone, there is another location which I believe to be the next point to mine in a direction a little to the south of east. Earlier I mentioned that schoolchildren reported to me that they had seen UFOs. It was here.

The first report was from two girls aged about thirteen. With the mother of one of them, they were looking for a lonely place to let off firecrackers, near to bonfire night. Accordingly

they climbed a road leading to a quarry on a hill. Above a mound of white spoil, they saw revolving coloured lights repeatedly ascending, then descending 'like a falling leaf', a motion one of them illustrated with a hand. Some weeks later, two other girls of about the same age, though unknown to the first pair, saw similar revolving lights, which then descended 'in a zigzag.' Their sighting was from a different and more distant location. The third account was from a boy, probably fifteen years old, living in a house on another hill to the west of the quarry. He saw similar revolving lights, but this time they descended so that they were between him and the spoil heap. A 'flying saucer' shape, with a dome above, appeared silhouetted.

In speaking about special places in the landscape, I am reminded of the fascination I felt, long before I knew Amy, for hills with what are generally regarded as prehistoric fortifications, in the form of banks and dykes on their upper slopes and summits. Amy quoted me a sentence from The Words.

'Turn ye and contemplate the amended hills.'

She told me that this sculpting was not originally for the purpose of fortification, but for the storage of a fertilising power, or life force, which could be released when needed by the land and things that grow on it. Later peoples used these hills as forts and camps.

As a student and in the early years of my marriage, many times I viewed the so-called British Camp on the eastern end of the Malvern Hills. I sensed that there was something special about it. On a visit to England in 1995 my wife and I climbed to the British Camp, where we found difficulty in grasping the immensity of the land sculpting involved. In the dry heat of that summer there was none of the magic left that I had felt in former times. Too many tourists, too many unheeding feet had trampled that special place and its spirit had fled.

Amy quoted a passage from The Words concerning one of the functions of standing stones:

> 'After the full of the moon, they shall bring the sick to the Wise Woman, and she shall gently lay her hands on each, and speak lovingly unto them. Then shall they be carried after her to the Stone, and each in turn shall she hold by the right hand, and her left shall she lay on the Stone, asking if it be the will of the Only One, that they may be made whole. And all shall give thanks and praise to the Great Lord for his mercy. And if it be so ordered, they shall receive from her herbs to drink and ointments to use. If it be not ordered, then shall they be brought again to her on the ninth day for the laying on of the hands as before.'

So that was one of the functions of the ancient standing stones. Some were healing stones. I am not aware of all the possible functions of single menhirs, but I do know that some marked leys, some were for communicating with the gods, as was Amy's stone, some were for raising power from the earth and some were to promote the earth's fertility. A stone might function in one or more capacity.

Dolmens, or as called in Cornwall quoits, are constructions of three or more upright stones, supporting a horizontal capstone, some of which are of enormous weight. Conventionally these are regarded as tombs, from which covering soil has eroded. This is true of some, and others were used as tombs in later times and heaped over with earth, but that was not their original function. Again these could have more than one function but their common purpose, was to raise the power from more than one spiral and point of power in the ground and were

located between these points. A dolmen supported by three stones, utilised power from three points, one with four uprights, power from four points, and so on.

Power was used by the vehicles (UFOs), for levitation, for raising other stones and for moving great quantities of earth. Beneath some dolmens, green stones have been found. The power could be focused upon these and they would store it, to be transported for a distance of up to thirty miles. There was a time limit for this, but I was not informed of its duration. Dolmens were also tables to bear offerings to the gods.

Stone circles could have up to nine functions, of which I can remember eight. These are that they were observatories, temples, power raising and amplifying instruments, gardens, for increasing ground fertility, centres of communication, places of healing and art galleries, in the sense that the stones were sculpted.

The Great Circle at Avebury is the largest in the British Isles. This immense complex, which was originally much more than just a stone circle, was the subject of deliberate and prolonged destruction by the Church. Fires were lit in pits at the base of the great stones in order to split them, so that they could be broken up. Avebury village is built from their rubble. And so through ignorance, fear and superstition the greatest functioning monument to the old knowledge was destroyed.

The shapes of the stones now appear rough and arbitrary where once they were sculpted. They were deliberately defaced so that now only hints of their original forms can sometimes be seen.

This circle was also capable of drawing, amplifying and directing power from the earth. There is a near diamond shaped stone situated a little outside the circle. I am unable to give its exact location, because I only know it from the photograph in a book which I showed to Amy. However, I see that a modern concrete slabbed path loops around three sides of it, and there is a fence by the fourth. This stone's longest point goes down into the ground, to tap the power source beneath. Power was sent from this stone, across the circle, to a stone opposite in the ring. Whether this stone still stands I do not know. From this stone the power went from stone to stone around the circle, simultaneously in both directions, until it returned to the same stone, creating a scar on the surface of the stone. In thus travelling around, the power was amplified, and then reflected back to the diamond shaped stone. From there a priest was able to direct power, which could be sent far afield. It was power from Avebury that lifted the great megaliths of Stonehenge. That is the extent of the account Amy gave me.

One thing more I can add. Old records and tales tell of people at night seeing a blue, flame-like light, leaping from stone to stone in these ancient circles. It has aptly been called dragon fire. How aptly we shall see when we look at Celtic symbolism in a later chapter.

Seemingly related to all this is a curious thing I cannot account for. In March 1994 I visited Bridport, a fishing village and holiday resort on the eastern part of Tasmania's north coast. Near the mouth of the Brid River there was a small car park affording a view over the wide bay, with a panoramic view of the mountains of Tasmania's North East.

The car park was bitumened, in English parlance tarmaced, and ringed with grey granite boulders. The short approach lane was also flanked with them.

Although the car park was rectangular, I had the seemingly ridiculous thought that it resembled a stone circle approached by an avenue. I found a forked, flexible twig, and began to investigate the parking area. Immediately I found a spiral, just a few yards in diameter, then another next to it, and so on until it appeared that the whole area was filled with them.

Down the centre of the avenue a line went apparently exactly in the direction of a mountain peak across the bay.

Finding the whole thing rather difficult to believe I brought my wife there the following day, and asked her if she could find anything. She found precisely what I had, using her fingers rather than a rod, since she has that gift.

This seems to be another example of the phenomenon I have noted on many occasions of subconscious guidance to construct in a geomantically significant way, during the course of ordinary mundane activities.

On a later visit we found that the whole area had been remodelled.

A further curious thing I have noted is that my dowsing rod will pull down when held over almost any of my ceramic sculptures, and my wife feels a pull from them.

At one time I had the opportunity of an open-air exhibition in the grounds of a large country house with views across a wide estuary, a truly lovely setting.

When I was about to set three tall, columnar sculptures, I wondered if dowsing could locate suitable positions for them. Consequently I cast about to see if I could find a line. I soon found one, then another intersecting it. And so on this spot I set one of the columns. The ground sloped to a lower level by the side of a lake, and I found a similar intersection of lines there. Since these sculptures are roughly six feet tall, they are constructed of several interlocking sections of considerable weight, and these have to be lifted over a steel rod, which runs up the centre, and hammered into the ground to ensure stability. My friend, who owns the establishment, was helping me with the lifting.

The third sculpture was positioned by the same method at some distance from the second. When we had finished assembling it, my friend stood back and noticed that all three columns were exactly in line. Using my dowsing rod I discovered a line running from the first, through the second, to the last set sculpture. Around the grounds I had set a number of smaller works, using the dowsing method for some, though not all. Every piece was connected to every other by a line of the indefinable force. I have no explanation to offer, but I have encountered the same phenomenon with a later exhibition.

Amy always insisted that the megalithic structures of the British Isles were made by the Atlanteans. I was of course aware that the conventional dating usually put them very much later, usually between three and four thousand years old. I was therefore very interested to learn recently that in 1997, holes believed to have held tall posts, indicating astronomical alignments, have been discovered at Stonehenge. They have been dated as being ten thousand years old. That rather put things back, and may cause some rethinking of conventional ideas, though I expect it will take a considerable time. Cherished ideas are not easily relinquished. Naturally I am aware of carbon dating and other dating techniques, but I know that Amy did not make claims lightly.

Ten thousand years takes us back to 8000BC, roughly 1500 years after Amy's date for the sinking of Atlantis. It is certainly a good step in that direction.

There are stones in Britain, which were carved in ancient times with what are known as cup and ring marks. These consist of shallow circular depressions, around which are incised rings. For many years I have had small astronomical telescopes, for I have always been fascinated by the night sky. There is a northern circumpolar constellation named Cassiopeia resembling a flattened W. I was looking at an illustration in a book showing cup and ring marks on a stone, when I recognised their form as a representation of Cassiopeia. I consulted an astronomy book,

and it seemed that I had not been mistaken. As a further check I marked the centres of the cup and ring marks on tracing paper. Using a photocopier, I adjusted the astronomical diagram to the same size. The match was absolutely exact. When I made this discovery I had no idea that I would write a book, and so made no note of the location of this stone. All I remember is that it was in a book authored by British researchers Janet and Colin Bord.

**Markings on the Panorama Stone,
opposite St. Margaret's Church, Ilkley, Yorkshire.**

In another book I found a further cup and ring illustration. This time I have a record. The marks are to be found on one corner of the Panorama Stone, opposite St. Margaret's Church, Ilkley. Here the cup and ring marks are joined by double lines, with short lines joining them, giving the appearance of ladders. I showed the illustration to Amy, and asked her if she knew what it signified. For a moment she was silent, as though listening, then, "Look up, turn round," she said. I knew that it would be useless to ask for an explanation. It was typical of the kind of thing that she would say to make me think, and it was a long time before the answer struck. It was a mirror image of the Pleiades, that open star cluster in Taurus that tends to disappear when looked at directly with the naked eye, but is a glorious sight with binoculars or a telescope, with the glow of nebulosity around the stars.

Look up, turn round; connect, connect, connect. It is a pity that archaeologists look so long at the ground that they fail to consider the sky.

Here is another strange thing, so strange that I can offer no explanation, other than that given to me by Amy and I don't pretend to understand that. All I can do is quote from the notes I made at the time.

I was waiting for the new moon but knew that it was not yet due.

Moon seen by my wife in northern sky at around 9.00a.m. on Monday, 23rd July or Tuesday, 24th July 1984. She was clearing the breakfast table. It appeared as a thin crescent,

like a new moon, illuminated on its left or western side. The sun, of course, was in the east. That week, I think on Tuesday, Amy said that she had seen a new moon early in the morning of that week.

I told my wife that I would be looking for the new moon later that week. She said that she had seen it one morning earlier in the week. I could not understand this, and found no moon visible in the evenings.

On Sunday, 29th July, I visited Amy and asked her how she and my wife could have seen a new moon in the morning, long before it was due. In any case the new moon is always seen in the evening, though it is possible it may be seen in daylight, though I have never seen it then, as a thin crescent. Amy said that she had been 'told' to go and look at this moon. I asked so many questions that Amy told me not to get so uptight!

On Tuesday, 31st July I saw the new moon in the western sky at sunset, as I would expect to see it. I questioned my wife closely about the moon she had seen, and it was now that I learnt about its position and the relation of its illuminated side to the sun.

I was faced with a puzzle. Amy had made a point of telling me what she had seen. I would not question my wife's perceptions any more than I would her truthfulness. Amy could have any motive conceivably, but what possible motive could my wife have? I should add that my wife had merely noticed the 'moon', but had thought nothing about its implications, or noted that the illumination was not on the side facing the sun.

After I saw the real new moon on the 31st July, I telephoned Amy, telling her that I had seen it. She had previously told me that there was a twin of the earth, permanently behind the sun from our viewpoint. I therefore asked her if there was a moon we did not normally see. She said that there was such a moon. I asked if it had an orbit which included going near to the twin of the earth, but got no reply.

Next I mentioned the curious illumination of the 'moon'. This implied a very strong light source, other than the sun. She said that there was such a source. Then, I said, "This must be permanently hidden from us by yet another body." This, she said, was so.

I next realised that somehow the 'moon' must be shielded from the sun's illumination. This implied a fifth body! Amy would not comment on this, beyond saying that I was not mistaken.

In connection with the 'moon' and other bodies, I said that they would upset the pattern of the tides, in so far as we believe them to be ruled by the pull of the moon and the sun, and to a much lesser degree by the planets. Amy pointed out that gales were currently sweeping Tasmania. I wondered if astronauts had seen something of these occulted bodies. And how was it that they were not known to astronomers? She could only speculate on this herself, but commented that astronomers, if they ever saw this 'moon' might keep silent for fear of ridicule.

A further question concerned how these bodies would affect Newtonian mechanics. Amy did not reply to this.

This is all quite bizarre. I simply don't know what to make of it. I am certain that my wife described what she actually saw. Having less interest in astronomy than I have, she simply thought that she had seen the new moon, without realising the impossibilities of date and time, or the direction of the body's illumination. Also Amy made a point of telling me that she had seen it, before I said anything to her about my wife's sighting. It seems obvious to

me that she intended me to think about and to discuss the phenomenon with her. But having done so, I can reach no conclusions. The more I probed, the stranger the implications became. One tentative connection I now make, so long after Amy's death, is with UFOs in this sense. Accounts of UFOs from around the world tell repeatedly that these things, however clearly seen, and however real they appear, frequently just vanish from sight. It would seem that they have the ability to enter into our order of matter and sense perception, and go back into some other order of existence. That 'moon' would appear also to share that duality. Is it used as a UFO base? My dowsing suggests that this is so. How many people have seen this 'moon', but failed either to realise that it was not our earth's familiar companion or, if they did realise, quite understandably kept it to themselves?

CHAPTER 4

The Book of Kells Decoded

We have seen a little of the tradition, the body of knowledge and belief, as it was passed on orally to Amy, but is there any evidence for it elsewhere? Emphatically yes, and we will look at some of the sources. In each case nothing has been written. The knowledge has been recorded in visual symbols. A certain prior knowledge is needed to interpret them, and one needs to develop some intuition, but the meanings are quite specific.

Kells, in Ireland, is where the Book of Kells first came to the knowledge of the modern world. Now it is the centrepiece of a lavish display of early Celtic manuscripts and related matter in the library of Trinity College, Dublin. There, under glass and in subdued lighting, one of its illuminated pages may be viewed briefly, as one files past in a seemingly endless queue of visitors. It is an incomplete set of the four Gospels, its origins uncertain, though it seems likely that it is Irish, probably from the 9th Century.

The Book of Kells is written in a fine, round, half-uncial hand, much acclaimed by today's calligraphers, but it is the quality of the illumination, which marks it out from the other works of the era, such as the rather earlier Book of Durrow and the Lindisfarne Gospels. The richness of the colour, the inventiveness of design, the humour, which I am sure is quite deliberate, and the sheer technical skill exceeds the others by several degrees, but it is the so-called carpet page for the Second Beginning of the Gospel according to St. Matthew, that is the single greatest masterpiece of late Celtic art. This is also the richest extant treasure house of the ancient knowledge.

This page, in the books on the history of art, is frequently described as a fine work of primitive pattern. It is neither primitive in concept or execution, nor is it merely pattern. Pattern there is, and in profusion, but it is all to a purpose. The skill that has gone into its making is literally beyond understanding. In technical quality it has no parallel, but commentators seem to have paid this little attention.

In the great downward sweep of the curvilinear letter X the borders consist of no less than eight parallel lines, curving in unison. With the aid of modern technology this could undoubtedly be accomplished today, though not on vellum with natural pigments. With nothing more than quill or reed pens and handmade brushes, the control of the hand and eye necessary for this is beyond my comprehension. And, I might add, I am not without considerable practise in using such tools, though my brushes are bought.

Then there is the minuteness of detail within the many shapes. Take the diamond at the crossing point of the X. This diamond is elaborated with additional corners. In four of them are men's heads with lines extending from the necks. It is an interesting exercise to attempt to trace these lines through their interweaving, and well nigh impossible, such is the complexity. These lines are rendered in golden yellow, but minute as they are, they are outlined in brown, each one curving gracefully in a thoroughly worked out design. Such a design is an intellectual feat paralleling the graphic skill. But for the evidence of our eyes, we would conclude it to be an impossibility.

Book of Kells

Spiral galaxy M101, in the constellation of Ursa Major

Such impeccable craftsmanship alone does not make a work of art. There is a grand sweep to this design, which absorbs all the detail into itself. All the elements contribute to the balance, and almost all the forms seem to be in movement, but are restrained from being frenetic by being held by one rectilinear shape. Though somewhat faded through the vicissitudes of time, the colour still glows in a rich harmony. Taken as a purely abstract design, it is completely satisfying.

But absolute abstraction in the past was very rare, unless representation was forbidden by religious edict, as in the Muslim world, and this page of the Book of Kells is far from abstract. Every element, large or miniscule is a symbol, and it is symbolic of some aspect of Amy's ancient tradition. I cannot interpret everything, but I have a substantial part of it. It is a microcosm of the physical and spiritual universe.

We are not dealing here with might be this or could be that. The symbolism is quite specific. At the crossing point of the X is a diamond, which in this tradition represents the earth or something precious within the earth. Man is inside the diamond, as we have seen, and the interweaving lines, in their going over and under, symbolise men and women in this life and in life in the other realm. So it is reincarnating man who dwells on earth.

From the diamond, the earth, the arms of the X sweep away into space to embrace all the bodies and formations of the universe, the galaxies, stars, planets and moons. All are circular forms, for all rotate, all is movement. Comets are shown as curved lines of changing width, linking body to body, sweeping even between galaxies.

These things were not known in the Ninth Century, or thereabouts. In that post-classical era, even the limited scientific knowledge of the Greeks was largely forgotten. Yet there was something else. Anti-dating even Egypt and China, there had been the civilisation of

Atlantis, greater in knowledge than our own, seeing the universe with a vastly expanded vision and depth of understanding. A goodly part of that knowledge survived the Sinking. No later culture was its heir, though some were influenced by it. Certain families among those warned to flee prior to the Sinking kept the knowledge in secret, for it was dangerous in the wrong hands. It was also perilous for its bearers among primitive people, who might confuse it with sorcery, and it had to be kept from the greedy and the power hungry. It was greed and irresponsibility, the misuse of knowledge, that brought about the decline and ruin of Atlantis.

Some of those who were versed in the knowledge became members of the religious communities of the Celtic Church, remaining even after the Roman takeover, and they used the sacred books to record it in symbolic form, for these were treasured possessions, and more likely than most things to be preserved. To many Christians this might appear an act of sacrilege, but the issue is not as simple as it may seem. The old knowledge and true Christianity are not at odds. The dispute would be with later interpretations of the teachings of Jesus, some of which may be found in the Bible, which was written many years after the death of Jesus, and with church dogma. The resolution of the apparent duality between the old beliefs stemming from Atlantis, and the person and teachings of Jesus, will be explained as we continue to explore the symbolism on this page of the Book of Kells.

I should make it clear that, although the Book of Kells is, without question, the finest of the books remaining from this period, and carries the greatest weight of symbolism, others also contain significant amounts. The scribes and illuminators who made the Book of Kells also varied in their degrees of skill. Of these, the artist responsible for this one design, was a genius. We should take that word here in its original meaning of 'spirit', for he was one who needed no further incarnation for his own development. He chose to return, with his great knowledge and skill, to create this work for posterity, for us in our time.

Photographs of spiral galaxies show great arms swinging out from the galactic centre, curving and trailing into space. There are many of these, of varying size, represented in this design, most with three arms, some with two. Between the spiral arms there are formalised plant symbols. They represent the presence of life, for life permeates the universe. In a broader sense, the universe is life, since all matter lives, being the expression of spirit in its many forms.

Nine is a very significant number in this tradition. The spiral symbols have nine meanings, the galaxies being one. At the opposite scale of magnitude they represent the atom, with its electrons apparently whirling about the nucleus. Within the human form are the chakras of eastern tradition, but knowledge of them having its origin in the west. In genetics we have the spiral chains of DNA and RNA. The spiral symbols also represent the stone circles. We have seen how a spiral of force has been found within the Rollright Stone Circle, and there are in excess of six hundred stone circles in the British Isles.

We have noted that there is a grid of points of power covering the earth, and that Amy's tradition says that each one is above a spiral water channel. Here then is another meaning. I should add that these spirals revolve clockwise in the northern hemisphere, anticlockwise in the southern hemisphere.

In the Words, what we term UFO's are simply called the vehicles. The Atlanteans possessed them. As with those seen today, they were, perhaps I should say they are, space-time vehicles. In recalling a former life, Amy told me how, just before the Sinking, she was a member of a

party which left Atlantis in such a vehicle. They landed at Zimbabwe, not the present African country but that enigmatic structure which so puzzles archaeologists, from which the country derives its name. The circular towers had been built for the vehicles to land on. The party erected the great monolith, or menhir, on that site, to be an instrument of communication with their people elsewhere, on Earth and beyond, and it also focused the power in the ground for use by the vehicles.

Finally the spiral symbol represents the Zodiac, linked as it is with the precession of the equinoxes and the cycle of the Great Year of approximately twenty-six thousand years. It was believed that these cycles usually end in destruction, when the majority of mankind are killed, and civilization disappears with little trace, leaving only a remnant to seed the next cycle. It was said that each cycle commences with people in a very primitive state, gradually, and with many a backward step, increasing their ability to order and control their environment. Eventually they gain sufficient knowledge to have the power again to destroy much of the life on Planet Earth. Something of a chilling thought, when we can now think of so many ways to do this, if we have not already begun the process.

All that I have described so far is an encoding of Atlantean cosmological knowledge and belief. That it could have survived so long, transmitted orally through almost countless generations, seems little short of an impossibility, but there are two things to consider. Amy told me about her guardian spirit, and I have written that she would often pause, as if listening, before answering a question. She was helped and guided in her answers. The memories of all who bore the 'knowledge' were helped in a like manner, so that The Words did not change in meaning and content. The only change was that of language, as it changed through the long ages. In a much more minor way, I too am helped. Sometimes answers to my questions arrive directly in my mind, but Amy made my pendulum so that I may seek guidance, specifically about matters concerned with this tradition.

The other thing to consider is this. Soon after I began talking to Amy, I asked her how old was this tradition. She would not tell me how long it had been passed down in her family, and I did not yet understand that it came from Atlantis. I knew that it had been transmitted through the female line, so I asked how far back she could remember the generations of her family. She then began to recite name after name. They went on and on, without hesitation or pause longer than to take a breath, until eventually she stopped, saying that her memory was not as good as it used to be. I said, "You must be back in Roman times by now." "Oh, beyond that," she said, and picked up the thread with another multitude of strange names. How many thousand years they represented I could not guess, nor would she tell me, but before her pause, I caught a name I recognised. Boudica. Amy seemed quite shocked that I knew the name in its original form, rather than the Latinised Boadicea. "Where did you get that name?" she demanded. I replied truthfully that it was quite common knowledge. "Somebody's been talking," Amy said. "When I was young," she said, "my Gran used to say that my hair was Boudica red. That was before I was ill and my hair fell out. When it regrew it was as you see it now." That was very dark, flecked with grey.

The two things then essential in the transmission of The Words were rigorous training in verbatim learning, and help accessed from the guiding spirits.

If we search the great X page of the Book of Kells, we find other circular symbols. I know the meaning of only two of them. One has three light toned circles against a black ground.

When first seen the black is more prominent, and it is only upon closer looking that the circles are seen. They represent Life, Death and Eternity. The other circle contains a germinating seed; life, ever beginning at some point in the cosmos.

Looking at the whole design of this page, all appears to be in movement as in the actual universe. The exception is the form at the lower right, resembling a reversed capital L. This symbolises the Creator, who, outside time, alone is still, the unmoved mover. Within the upper segment of this shape are four small figures. Amy would not tell me whom two of them represent. The other pair are the Evil Ones, Até and Sathanoz. It is the role of Até to tempt mankind to such things as self-righteousness, judging others, envy, self-importance, vanity, all those sins of the law abiding, worthy citizen, who sees no wrong in them. It is Sathanoz who tempts us to the more obvious and recognised wrongs, to violence, theft and murder among them. Até and Sathanoz are gods. "How can this be?" I asked Amy. "Why are they there within the Creator symbol?" She answered me, "For how shall a man's soul be strengthened, if he cannot be tempted?"

In this tradition we are intended to grow and learn through many lives. As much as by any other means, we learn through our mistakes. Our lives on Earth are real, in a sense. We may be happy or we may suffer greatly. Our lives may be short or long. All is a result of what we have been, what we have done and what we decided we needed to learn, prior to birth. Whatever happens to us, ultimately we take no harm, for what we seem to be here is not our real, eternal self. Here we act a part, as on a stage, and our environment is the stage set. Those who interact with us are in like case. But once here we have free will. We may succeed or fail in the goals we set before our birth; usually our performance is a mixture of both. Contrary to Christian, or rather church teaching, with Last Judgement, Heaven or Hell, or possibly Purgatory or Limbo, we have another chance, and another, as many as we need, until we have learnt all we can from earthly life and can proceed to other lives.

Of course these beliefs are related to certain Eastern religions, though they are not identical. In Amy's writing, quoted earlier, she says that her people travelled widely, reaching India. But teachers from Atlantis had gone there much earlier, when they went 'everywhere that the foot of men shall tread.' It was these who taught belief in reincarnation to the peoples who inhabited the Indian sub-continent at that time. Over time the original teaching changed, and much extraneous material accreted around the original, until it became greatly changed, yet belief in reincarnation remained.

We might speculate about the social consequences today, were the ancient beliefs to be widely accepted. In our precarious world situation, many peoples search for spiritual security. Some seek it in the dubious certainties of fundamentalism in Christianity. In the Muslim world, where pressures and problems are rather different from the West, we see a more fanatical and violent version of the same trend. It is interesting to note that under the British Raj in India, a survey was made of the proportion of people of different religions, who committed criminal offences. Christians came out on top, Muslims next and Hindus with the lowest rate of crime. Could this be due to their belief in karma? Was this more real to them than the Last Judgement was to the Christians? It is a question that would bear researching.

When we looked at near death experiences, we saw that the centre of consciousness may leave the body and return. Many people report very similar experiences when no trauma has occurred. Mystics, especially in the far eastern religions, strive to accomplish this, but

it frequently happens spontaneously among quite ordinary people. I do not wish to enter the seemingly interminable debate as to what precise part, attribute or whatever it is that travels, spirit, soul, astral body, and so on. I simply refer to it as the centre of consciousness. During this travel the body usually, though not always, appears to be asleep, but the centre of consciousness, the mind, is elsewhere, at any distance from the body.

When discussing this with Amy, she was content to call it astral travel, and said that she could perform it. She told me that when her father was dying in England, while she was in Tasmania, she visited him, and he knew she was there. I asked her if she could teach me to travel in this way. "I would not wish to take that responsibility," she replied. Pressed to explain, Amy said that when the spirit vacates the body, something else might enter, which could not be dislodged. That would be possession. Note that she used the word, spirit. She added that at such times, when the spirit is to travel, there were words to be said and colours to be worn, but she refused to enlarge upon that.

We must return to the Book of Kells. Near the bottom of the page, below and to the left of the stepped cross, is a group of animals. Centrally placed are two mice supporting a disc between their noses. At Trinity College, Dublin, I saw a vastly enlarged diagrammatic representation of this page, with a cross on the disc. This was quite false. There is no cross. On a subsequent visit I was pleased to note that this diagram had been removed. What actually is on the disc is a faint, horizontal line of dots bisecting the circle.

This disc represents the earth, and the line is the Equator. Its purpose is made clear by the other animals. The lower pair cannot readily be identified, but they certainly appear to be placental mammals. On the other hand the upper pair are quite clearly marsupials. Their large folded rear legs identify them as hopping creatures, as do their large balancing tails. The facial features are also unmistakably those of Australian animals. The one on the right is a small wallaby, very like the pademelons I see in Tasmania. The left hand creature resembles a bandicoot. These little creatures sometimes dig shallow holes in my lawns.

So here we have a statement saying, "we know, we have seen." Such knowledge of the earth would have been passed down from Atlantis, but to depict marsupials so clearly, the artist must have travelled and seen. Astral travel. And: why mice holding the earth? Our planet is a very small thing in the totality of creation.

The letters on the page are XPI generatio, an abbreviation of Christi autem generatio, but as symbols they become something very different.

We have seen that the letter X has mankind within the compass of the earth, but the X also extends into the depths of space, amid all the bodies, formations and forces of the universe. Also we have seen the life symbols within the galaxies. This is telling us that Man is a universal being, not simply a creature of this planet. Remember that the vehicles are space-time vehicles. In these beliefs, modern man did not evolve on Earth from more primitive hominids. He was brought here, and the races of mankind had different planetary origins. This is the thought recorded here in the Ireland of the Celtic Church, which the keepers of the knowledge had infiltrated.

Let us consider now the letter P. It rises from the stepped cross. Such a cross is the symbol denoting a Sky God. If we invert the P, in the form given here it becomes a J. So P and J terminate in a head, drawn horizontally, favouring neither letter above the other, except that it first appears to us as P. And that is entirely appropriate as the initial of Pan, who incarnated as Jesus; one being in two aspects united in the one symbol.

Did I mention that art critics dismiss this work as 'primitive pattern'? Pan-Jesus who incarnated as a great teacher: not as a blood sacrifice, not as a passport to Heaven through faith in Him, but in order to teach us how we should live. Pan had incarnated before that time as a teacher, and we may rightly believe that Jesus may come again, though with another name. But by whatever name some unborn generation may know him, he is Pan.

Unfortunately, when teachers are sent to us, instead of quietly adopting the spirit of their teaching, absorbing it into our daily habit, we turn it into religion. Then it becomes a 'them and us' affair. We of the Faith are right and good. Those without are wrong and bad. Worse yet, priesthoods spring up interpreting the teacher's words, and abrogate power unto themselves. Thus the Church deliberately suppressed belief in reincarnation, in which the early fathers had believed, and gave to its priests the supposed power to forgive sins, and thus prevent our damnation at a mythical Last Judgement. So the people were enslaved spiritually, and when eventually many broke their chains, they threw away all belief, having being deceived.

The letter I cuts through the P-J, behind the head, linking all its meaning to the universe, via the line which sweeps from the top towards the circular symbols. The teachers come to all inhabited worlds. On the right a line arcs across to the Creator symbol, through a life, death and eternity disc.

Clinging to the left hand edge of the downward curving limb of the X are three half figures. Two, linked together, hold books, for their words, and the remembrance of their deeds, were preserved among peoples in widely separated regions of the Earth. The lower one is the Lord Buddha, the other, in the Americas known by various names, we may call Con-Tiki Verrucocha. Like Jesus, they were incarnations of Pan.

The uppermost half figure, and the latest in time at the making of the Book of Kells, is remembered far and wide as King Arthur. So many legends have been made concerning him that all truth has been obscured. Amy said simply that he came to make safe the Old Things. By that she meant that he delayed the Anglo-Saxon conquest of Britain long enough for the oral tradition, The Words, to be certain of being passed on, and also for some material things to be hidden. She would not tell me what these were, and I do not intend to become involved in fruitless Grail speculations. Over the centuries there have been quite enough of these.

Directly below the letter I there is a black, dead, animal, linked with the galactic symbol, and also with one for life, death and eternity, for life and death are the order throughout the universe, but also is the eternal life of the spirit. Little dots form lines around the body, and these are found in many other places. These are the seeds of life permeating the cosmos. It was believed that they were carried by comets to all regions. Ascending from the base of the X is a line, which gradually rises away to the left, expanding to meet another line which descends to surround a large circle. At the widened junction of these lines is a plant symbol, two leaves and a stem. The curving lines represent comets and the plant symbol represents life. Looking around the design, we see many more comets and life symbols. Fred Hoyle, the distinguished astronomer, has written that he believes that viruses are carried by comets, and that Earth is periodically showered by them, bringing epidemics of viral disease. That would seem to be a negative version of this concept. Perhaps one day science may detect a positive aspect.

To the left of the diamond form, in an angle above the Arthur part-figure, dots form the spread wings of a moth. In this tradition the moth represents the spirit. So at the base of the design is a representation of death, and near the top we find the spirit. The moth is attracted

to light. The purpose of life is eventually to transcend the material body and to live as spirit in the light.

Right at the top of the page, above the diamond of the earth, is a head. This is the Earth Mother, the goddess who is the spirit of the living Earth herself. Her name is Hera. That's another name the Greeks got wrong!

Before leaving this page of the Book of Kells, there is one more thing to look into. This is the area between the pincer-like arms of the X, to the right of the diamond. The upper and lower halves mirror each other, pivoting about a horizontal axis. Amy was at pains to point this out to me, but would not immediately tell me its significance. Some scientists have speculated that through and beyond the black holes lies another universe, possibly very like our own. Possibly also it is from this mirror universe that UFOs appear in our time and space. That is the meaning of the reflecting halves, and it is an astounding statement of knowledge, originating out of the depths of time, in a civilisation which knew far more than ours.

Many other pages of the Book of Kells bear symbols of ancient belief and knowledge, though none approaches the great X page in richness and complexity. A fine example of these other pages is the ornamental text, Tunc crucifix rant XPI cum eo duos latrines. Ch XXXVI:38

This displays a large capital T, of the curled form current in the script. There are three dragons on the page. The largest forms a border and the others make the shape of the T. The dominant colour of the largest dragon's head is red, and it breathes fire. Next in size is a dragon whose head is predominately golden, whilst the head of the smallest is green.

The dragon represents positive forces. In this case the three dragons represent forces connected with the earth, and also with the universe. They might also be described as three aspects of a universal force in intimate association. The fire breathing red dragon is the power within the earth, which has its origin in the galaxies, that power which was used in ancient times, and which Amy was able to use, as I saw. The golden dragon stands for communication, such as that which Amy received concerning my first standing stone. The smallest, the green dragon, symbolises the life force, and is the most important of the three. There is teaching here. As Amy said, the importance of things should not be judged by their size. Is the atom of less importance than the solar system? Or is the dance of the atom's electrons in some sense a doorway to another universe?

One final word about the minute scale and extreme complexity we have noted in the X page in the Book of Kells. When I questioned Amy about it, she told me that magnifying glasses had been passed down from the remote past, presumably from Atlantis. She also described brushes 'made from one hair of a badger's foot.'

Here we will take a little diversion which will lead us back to the Book of Kells.

Arthur Guirdham was a psychiatrist, practising in Bath, in the English county of Somerset. He was also a writer, and his books centred on memories of past lives, his own and those of a group of people who had been with him in the past and present. In these lives they had belonged to communities with dualistic beliefs. Briefly, dualism propounds the belief that God and the Devil, the forces of good and evil, have always existed in opposition. One period in which the group were together was in the Thirteenth Century in the Languedoc, in south west France. They adhered to the Cathar faith and were regarded as heretics by the Catholic Church. Eventually the French King proclaimed a crusade against them and large numbers

were put to death. A last group of them were besieged in the castle on Mont Ségur. After putting up fierce resistance, eventually they surrendered and over two hundred were burnt at the stake.

Very briefly these are the historical facts, but another is that the people of this pocket of what is now France were the best educated and the most skilled in many of the arts and crafts in Europe at this time. They also had considerable medical knowledge, but history has not been kind to the Cathars, branding them as austere, fanatical bigots.

Gradually patients of Arthur Guirdham and other people began, hesitatingly at first, to tell him of their far memories. Eventually it became clear that he too shared in them. Through this process, and the appearance in spirit form of other members of the Cathar group, it became clear that the historical picture of the Cathars was a distortion perpetrated by their enemies, the Inquisition and the Catholic Church in general.

The dualistic belief they held was that the world was created by the Devil and essentially evil. God was the force for good, perpetually opposed to the evil upon Earth. The Cathars were Christians, but they did not believe in Christ's blood sacrifice for the salvation of mankind. They took him for a model of how people should live. His only miracles were those of healing. In this they were at one with Amy's tradition.

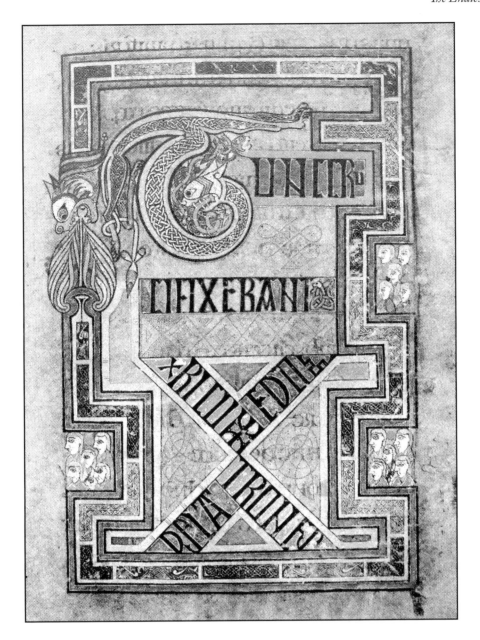

The Dragons in the Book of Kells

Following the memories of their Cathar incarnations in the Thirteenth Century, other memories began to surface, which puzzled those involved initially, since the landscape they glimpsed and the clothing they wore, were entirely different. Also strange events happened to them in Cumbria, the English Lake District, that mountainous and dramatically beautiful north western corner of England.

As the memories surfaced more and more, and deceased members of the group appeared and instructed them, it became evident that they had all been adherents of the Celtic Church in the Seventh Century. Again their beliefs were Christian, but dualistic. It does not seem that they thought that the Devil created the world, rather that they had an intense love of nature and a reverence for all that lives, be it stone, plant, animal or human being. God was

not alone and jealous, for the old gods were revered as intermediaries with the great Creator. God lived in all life.

In this it seems very little different from Amy's teaching. We have seen that the Celtic Church was taken over by the Roman, following the Synod of Whitby in AD664. Guirdham gives an account of how this was done in Cumbria, how healing, the dominant function of the Celtic priest, using the chakras and native medicinal plants, gave way to magic, in the form of the sacraments. Women could no longer join the priesthood and celibacy was imposed. At the instigation of the Roman priests mobs drove the Celtic priests and other healers away with violence and injury, to safer parts, only for these to be subsequently Romanised, until they had nowhere to go.

The Book of Kells is of rather later date. Those within the Church, secretly keeping the old knowledge in their hearts, encoded it in the patterns and illustrations of this marvellous work, for a posterity when it would be understood.

But where is Dualism in all this? Amy's tradition has the Creator and the Devil as co-existent in and out of time. Até and Sathenoz are the active agents of the Devil upon Earth. Pan and certain of the other Sky Gods are the active agents of the Creator. But therein is purpose which, from my small understanding of Cathar doctrine, I cannot see in their form of dualism, and that purpose is expressed succinctly in Amy's saying, "How shall a man's soul be strengthened, if he be not tempted?"

To attempt to give a plausible account of Arthur Guirdham's lengthy involvement with the spirit world, and the gradual unfolding of far memory, cannot be done in so few words. For this his remarkable books must be read. The most relevant in this regard are, The Cathars and Reincarnation, We Are One Another, and The Lake and The Castle, particularly the last two.

This symbol was seen by one of Dr. Guirdham's patients/associates, when a female Cathar Parfait appeared to her in her bedroom. About her waist she wore a girdle with a clasp bearing the above symbol. I showed the figure in the book to Amy. She immediately said, "Triples on a Cross." The T shaped 'triples' represent where we have been, where we are now and where we are going in our many lives. The central vertical line symbolises the one who moves us.

CHAPTER 5

The leys worldwide. Map dowsing.
Guidance from leys and dowsing.

It seems that I had some unconscious awareness of leys, long before I read about them. When I had been teaching for some years, I decided to add to my qualifications by studying pottery. At the college of art, which I could only attend in the evenings, since I was teaching full time in a grammar school, I found myself in the curious position of being again the company of my ex-sixth form students.

It was in 1960. If the Beatles had invented themselves at this time, I was unaware of it, but it was in the era when beatniks were both dropping and hanging out, accompanied by guitars, and girls in long shapeless garments, festooned with beads, hair and fringes. It was a time when many young people were questioning the values of society, and the word 'square' entered the vocabulary in a non-geometric connotation.

My job required that I was strictly a collar and tie man, though I had some sympathy with these peoples' questioning of values. Unfortunately I failed to see what positive things they proposed to substitute. Then I had my straight-line dream.

In this, I was in discussion with my younger fellow students, and we were incensed that so much of our island of Britain was locked away from the people. We decided to make our protest by each choosing a compass direction, from our West Midlands location, and walking in a straight line to the coast. We were not beatniks, but proposed to call ourselves Beatles. I remember trudging and stumbling through fields, hedgerows and woodlands, over hills and across roads until, exhausted, I woke up. So was this some precursor of my much later fascination with leys?

When eventually I did hear of the Beatles, I considered them to be in breach of copyright!

Having read about leys or ley lines in books, referring to those in Britain, I wondered if they were confined to certain places, or if they existed everywhere on Earth. When I asked Amy about this, she said, "Come out onto my lawn." As I have already indicated, Amy's cottage was set back from the street, behind another house, with her quite lengthy front lawn invisible from the road or footpath. When we were outside, Amy bade me stand behind a small fruit tree, look over it, and align it with another on the far side of the lawn. "Now tell me what you see," Amy said. Directly above the second tree was a sharp change in the angle in the skyline of a nearby hill. It struck me that such a feature might well have marked the passage of a ley in Britain, where in prehistoric times, people made skyline features for that purpose. So Amy had marked a ley from this change in the angle, passing near to her standing stone, by planting trees.

I asked her where the ley's path continued, the view in the other direction being blocked by nearby rising ground. Amy waved her arm vaguely and said that she thought it might go over the hill beyond. In other words if I wished to know, I would have to find out for myself. She was very good at making me think.

As I was very busy at that time, I did not immediately follow this up. Then one afternoon I was driving along the coast road near my home, when I looked toward a small rocky island,

which at low tide is joined to the shore by a natural rocky causeway. I thought of St. Michael's Mount, off the coast of Cornwall, joined to land by a causeway at low tide, the Itkis of old. It is said that the longest ley in Britain begins there, traversing the island to the Suffolk coast in the east. One of these intuitive feelings I sometimes have told me that this was the beginning of the ley. Again it was some time before I did anything more about it. Eventually I drove up the road which crosses the top of the hill Amy had indicated. From the highest point, through a gap between the houses, I looked back toward the angle in the first hill. Through my binoculars, the rocky peak of the island showed in the angle of that hill as in the back sight of a rifle.

A while before this, on a family outing, I had driven along a road from which I had noticed a tall spoil heap of white material on the skyline, formed by a nearby ridge. I had a curious feeling about it. It seemed to have a significance that I could not define. Later, when I stood on the second hill, and looked back towards the island, I turned and saw this white mound, apparently on the continuation of the ley. I borrowed a prismatic compass and returned to the scene. When I worked out a back bearing from the island, I found that the spoil heap was exactly on line. So my intuitive feeling was explained. What was not explained was how a recently man-made feature should so clearly mark a ley. Later I went to the gravel quarry where the heap was situated, and stood before the white mound with my binoculars. All the other features lined up before me. Is it any surprise to learn that this white mound is where all five high school students had seen UFOs?

It does happen that leys are sometimes marked, quite unconsciously, by people going about their normal business. Whether we like it or not, and whether or not it offends our sense of human dignity and free will, we can be guided by spirits to do such things. It seems to occur so naturally, and in a manner no way detrimental to our lives and enterprises, that we are aware of nothing. One might imagine the quarry owner's reaction if told that spirits had guided him in placing that spoil heap, when he of course knew that it was the most convenient and logical thing to do. Something else I might add here. Wherever a bridge crosses running water, a ley crosses it at some angle, yet the ley was there long before the bridge.

My curiosity about this ley grew. I bought large-scale Lands Department maps and taped them together. Stretching cotton thread from the rocky island through the other points already found, I determined that the ley did indeed go through Amy's garden. Much further on it crossed a blue dot, the size of a full stop. This marked a thermal pool. I had been there and seen the bubbles rising from the sandy bed, together with warm water. At a little distance great trailing fronds of algae waved and wafted in a ghostly dance. In ancient Europe, such a place would have been a sacred site. Perhaps it was for the Tasmanian Aborigines, not so long ago. For a great distance I could find no obvious features to mark the ley, until it came to a place in a river named the Devil's Whirlpool. This I have yet to visit.

A ley runs along the side of this road near Latrobe in Tasmania.

In old times it was called "the Ley of the Waters," Amy told me. We have already seen the hemispheres illustrated in the Book of Kells. Amy once quoted to me a short passage from The Words. It was an injunction to teachers setting out from Atlantis at the time of the First Sending:

> Go ye into all the lands, everywhere that the foot of man shall tread. Take ye love, peace and knowledge.
> It is said that they set forth with the blessing of The Creator.
> They that journey afar, they shall climb My hills, they shall descend into My valleys, they shall eat of My bounty, they shall drink My sweet water. My hand shall guide them; My peace shall be upon them.

Older by far than any papyrus or inscription on stone, these words come down to us from an age before ours began. There is some quality in them that moves me beyond anything I can express.

The first pendulum I made, when I became interested in dowsing was, as I have said, a plastic cotton reel on a short length of cotton. It only worked in Amy's presence, otherwise it was useless. After a while Amy gave me a pendulum she had made especially for me. I will not describe its construction, for I am sure that an attempted replica would not work for anyone else. When she told me about it, she asked me to step outside into her front garden. There lay the pendulum, draped across her standing stone. When I moved towards it, she restrained me, saying," I must give it to you." With this new pendulum, I found I was able to ask questions concerning the things I am writing about, and obtain answers consistent with the old knowledge. Always though, I had to ask if my question was allowed.

One thing I soon discovered was that with my pendulum I could find leys, if I was near enough to them. I would ask if there was one to my right. If the answer were no, indicated by an anticlockwise revolution, I would ask if it were to my left. For a yes, it would turn clockwise. So by a process of elimination I would find a ley.

This was rather laborious, but after a time the pendulum began to behave oddly, almost I felt it were trying to tell me something. Eventually I realised that on the ley itself it would oscillate backwards and forwards along the line of the ley.

I had heard of people dowsing for water, minerals and even archaeological sites with a map. I wondered if I could do the same with leys. Over a map the pendulum behaved exactly as it did on the ground, but there was a further development. If I held a pencil in my left hand, and pointed with it to a location on the map, the pendulum in my right hand, away from the site indicated by the pencil, behaved as though it were itself over that point. The pencil was able to pin point the exact location much more easily than a pendulum held over it. So map dowsing for leys became very easy.

Soon I found that there were points where many leys crossed exactly, radiating from them like spokes in a wheel, though not evenly spaced. Mountain peaks were often such centres, for Tasmania is a mountainous island, though other ley centres were at apparently unremarkable locations. One intrigued me greatly for it was, and is, my garden.

Another, which I had found from a map, is on open land in an area between three mountains, and near a rodeo ground. Nearby is a complex of wooden buildings, once used by workers on a hydro-electric scheme. Since then, it has been used by school parties for outdoor activities. On one occasion I was one of the staff members in charge of a group of younger high school students. I had brought with me a bundle of forked willow rods from my tree. On four successive days I took groups of twelve girls and boys to the ley centre area, and demonstrated how my rod pulled down each time I crossed one of the leys. On average nine kids from each group could get a reaction. One little girl I shall never forget. She stood goggle eyed, calling for me to watch, as her rod rotated round and round.

When I asked Amy about the function of leys, she hinted that there are many, but was reluctant to say more, presumably because she was warned to be cautious. Eventually she told me two things. One was that they gather information about the state of the land, though she would not say who or what receives the information. The other was that the leys are spirit paths. Again she would not enlarge upon that, but I have some thoughts concerning it, which my pendulum appears to confirm.

In dream we travel astrally, though we do not usually remember. Beneath or beyond the ego, our unconsciousness is many layered. Where we go and what we experience in dream feeds the totality of our being, which we again know when we are once more free of the material body. What the ego usually remembers of dreams is only a scrambled interpretation. The leys are the paths our spirit bodies travel in dreams that remain terrestrial, but they also connect us with other realms of being. Space and time are quite different in the spirit world, and other universes co-exist with and interpenetrate our seemly solid world of tangible matter.

In a later chapter I describe how I am sometimes able to help people to free themselves from their earthly environment, when they, for various reasons, which I will explain, find it difficult to go on after the death of the body. If they are willing to heed me, I can call them to me from a great distance, from Britain or America for example. They are with me, detectably, on the instant. So, granted this, spirit travel along the leys is instantaneous, or perhaps I should say outside our time. This is a very simple thing, and nothing morbid or spooky, for it concerns the natural continuation of life.

One further point: There are many more leys than is generally realised, main ones and subsidiary ones which connect to them. Unless they have been damaged or destroyed, no one has far to go to find a ley, outside densely built up areas.

Abuse or inappropriate use of land destroys, or at least damages, leys. Behind a beach, backed in places by cliffs yielding fossil seashells, a new housing development was built. The only access to the beach was through this. In the larger surrounding areas there are many leys, but when I walked with my wife though this new subdivision, the whole place felt dead. That is this only way I can describe it.

Hills and mounds topped with a clump of trees, whether they are natural or man-made, are frequently ley points. Compare this photograph by Alfred Watkins with the Paul Nash drawing.

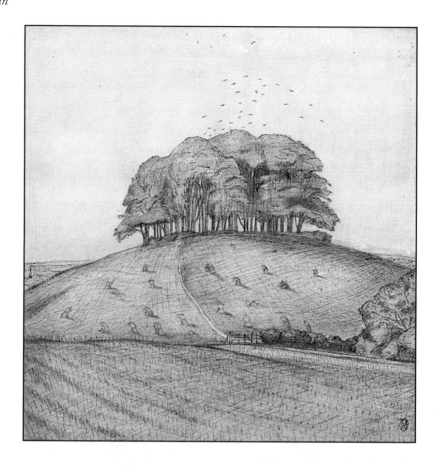

THE WOOD ON THE HILL.
1911 Pen and Ink with Monochrome. 22x14 ½ ins by Paul Nash

I don't know what prompted me, apart from saying that it was one of my feelings, but I used my pendulum to ask if there was a way of restoring the leys in that area. Yes, came the answer. Further questioning indicated that I should set a stone at a specific location near my western boundary fence. I did so. Some weeks later we revisited the beach. Walking through the built up area, physically there was no perceptible change. Houses and gardens were the same, but now there was a feeling of life, a lightening of the former depression. I still think that it was a planning error of wonderful proportions to allow building in such an environment, but something vital has been restored. I wonder if any of the people living there detected any difference. Perhaps I should go there again and knock on a few doors. "Excuse me, but have you felt better since I stuck a stone in the ground in my garden, thirty five kilometres from here?" Then again, perhaps I won't.

Regularly I ask if I should set more stones. Frequently I have to do so. Now the process is simpler. When a stone is to be set a line forms on the small concrete yard beyond the back door to my house and all I have to do is follow it with my rod to the location by one of the boundary fences where the stone is to be placed. All these stones, as far as I can determine, are intended to restore the life of damaged leys, but usually I have no idea where these are. The only times I do know are when I have asked if I can help a particular place which feels 'dead'. Later I find 'life' has been restored. This seems to take about three weeks. It is a function that appears to have been given to me, which I willingly perform. My wife plays her part, because

she can use her extended fingers, in the manner I have described, to check my feelings about a place.

It is not only building that disturbs leys. Tree felling also does this. While we were visiting England, it was evident that leys no longer exist near the motorways. Overhead power lines, especially high-tension lines carried on steel pylons, prevent leys from crossing their path. I would doubt if any ley crosses a battlefield, or any place where some horrendous man-caused event has taken place.

I think I have always had some awareness of leys, or at least of some features that commonly mark them in Britain. In my early childhood my parents took me camping on Cannock Chase in Staffordshire. On a walk across the Chase I saw a tree, which fascinated me as no tree before had done, and I asked my mother what it was. A Scots pine she told me. When I was an art student I came upon a reproduction in a book by the English artist Paul Nash. It showed the fiery trail of a shooting star arcing across the night sky above the billowing tops of a Scots pine. Like the tree on Cannock Chase, this too fascinated me. I could not have given any reason for this strange and powerful feeling. A great many years later, in The Old Straight Track, I read Alfred Watkins's statement that Scots pines are frequently to be seen marking the paths of leys, with their tall distinctive shapes.

FALLING STARS.
1911. Pen and Ink, Chalk and Charcoal. 12 ½ x 9 ins. Paul Nash

On a recent visit to England, my wife and I walked along the bank of the River Severn, near the lovely old town of Bewdley, which I had known in my youth. Across the river, on

a tree-clad mound, stood a Scots pine. In that curious way I can be aware of such things, I thought it marked a ley. Using her fingers in the manner I have described, my wife felt its pull. Since then I have found other Scots pines that produce a pull on my dowsing rod. Even their cones do.

Another drawing by Paul Nash shows a clump of trees on a knoll. Again I felt strangely about this drawing. Many such mounds, whether crowned with trees or not, mark leys and were raised to do so in ancient times.

Silbury Hill, not far from Stonehenge and Avebury, is the largest artificial earth mound in Europe. It is not simply a heap of soil, having been carefully built over an interior construction. Not surprisingly it is connected to leys.

On New Years Day, 1994, my wife and I visited a place we had long resisted, a supposedly Swiss village constructed near the Tamar River in Tasmania. It is intended as a tourist attraction, with 'gifte shoppes', tearooms and a restaurant, grouped around a courtyard. Associated with it are retirement homes, a golf course and an artificial lake. All the buildings are in what is intended to be a Swiss style, though I doubt if any Swiss tourist would recognise it. We heartily dislike such fakery.

We happened to be in the area and were both curious and hungry. It was not as visually awful as we had dreaded and there was a calm and peaceful feeling about the place. We also had a very acceptable meal in the restaurant.

Afterwards we went out by a different way from the main entrance and were surprised to find ourselves confronted by a large earth mound with a flat top. It looked like a smaller Silbury Hill. Not only did it look like it, it felt like it. Again I am at a loss to explain this feeling, but we both felt it strongly. We saw a spiral path winding clockwise to the summit. I went back to the car park and retrieved my dowsing rod from the car boot and then we climbed to the top. In the centre of the summit my rod pulled right down. My wife could feel, and my rod indicated, lines radiating from this central point to many distant peaks in the ranges of mountains and hills visible from this vantage point. So here is a mystery, a man-made hill of very recent origin, made from the soil excavated from the lake, which is a ley centre. Not for a moment do I think that the contractor, or whoever planned the work, was aware of the leys. It is an example of how people can be influenced to do such things by the spirits who control the leys and all connected with them. On a more recent visit to this place we found a wooden shelter had been erected on the summit of the hill. The ley's still centred upon it but it has destroyed the resemblance to Silbury Hill. No one can be blamed for this, but to us it seemed like a desecration.

We encountered another example at Blenheim Palace, built for John Churchill, Duke of Marlborough, at the time of Queen Anne. After a conducted tour of the areas open to the public, we walked along the straight path toward the great column of the Marlborough Memorial. In the opposite direction this path is in line with the main entrance of the palace. As we walked, we became aware that we were on a ley. It is a feeling impossible to analyse or describe in words. Later my pendulum indicated that it was indeed a ley and also that neither of the architects who designed the building and related areas, Sir John Vanburgh and Nicholas Hawksmoor, were aware of such a line, yet it was clearly defined by their structures.

The awareness of leys is only a part of a special kind of feeling for the land in general. Language does not have words to describe this adequately. Rather than attempt to describe or

define it I will suggest two experiments which might help some people to experience a little of this feeling. Stand near an industrial site. Stay there for at least ten minutes, taking in all the forms, all the textures of materials and surfaces, the kinds of colours, the noises and the smells. Let the mind be as free of thought as possible. Just let it soak in. From there go to a country area with plenty of trees, and if possible where hills can be seen and near a river or stream. Again allow the mind to rest, while the senses are aware of all around. See, listen, feel, be aware. If this kind of attention-without-thought is practised, over time it may be that these feelings, this special awareness may develop. Then certain places, certain landscape features will take on an indefinable, yet very real significance. The land will begin to speak and will be heard.

The other experiment is to find some reasonably pleasant country landscape, which is traversed by pylons carrying high-tension lines. Look at the scene through and/or below the lines and between the pylons. Then turn and look in the opposite direction, where there are no power lines or, if it is possible, see the same scene after going beyond the lines, so that they are behind you. Note the difference in feeling. I can only speak from my own awareness and that of certain others I know. Where the power lines cross the scene there is a deadening of the landscape. Where the lines are not part of the scene, there is liveliness, a lightening of feeling. If this can be felt, again it is the beginning of awareness.

I see this thing with the power lines, yet I would not wish to be without electric power. Neither would I wish to be without the goods produced by industry at those industrial sites. That's quite a dilemma, and I don't know the answer to it.

Originally I trained as a painter, but convinced myself that I was less than good at painting. I had always had a special, if indefinable feeling about the land, and I wished to paint landscapes, but few that I attempted succeeded in my own terms. So I turned to other things, where I had more success. After I had known Amy for some time, I looked through some old landscapes I had put away. The thought occurred to me that perhaps the better ones were done when I had been sitting or standing on a ley. My pendulum indicated that this was so. At this time my ideas for sculpture, which for years had been so prolific, dried up, so I went out into the Tasmanian countryside and painted landscapes. Now the majority of them were satisfactory. When I saw something that interested me, I cast around with my dowsing rod and found the nearest ley. I never had to seek far. From the ley, the landscape appeared more harmonious in its forms and colours, and it was suffused with a feeling of peace, a certain quality difficult to describe. I did not have to be looking along the line of the ley. Just to be on it was enough. In relation to this, I recalled reading about people having a feeling of nausea when on a ley. Amy told me that this could happen to people who are opposed to the idea of leys and related matters.

I have mentioned that I was disillusioned with painting for a time. That time was longer than I care to contemplate. During it I decided that if my creativity were severely limited, perhaps I could channel what little I had into something that was at least useful. Therefore I trained as a potter, long before I came to Tasmania.

Shortly before emigrating I began to be interested in ceramic sculpture, but it was only after my arrival in Australia's island state that I really began to find my feet in that medium. My work certainly took a leap forward, and I attribute this both to the natural environment and to the many new things I was reading about. At the same time I was making functional

pottery, mugs, teapots, casseroles, bowls—all the usual things. Both sculpture and functional things found a ready market in those prosperous days of the 1970s and early 1980s.

Then began a problem for which I could see neither cause nor answer. In firing sculpture I had few difficulties, although I often stretched the resources of the medium. However, firing functional ware became very unpredictable, although everything I did was recognised sound practice. My success rate got worse and worse during the early months of 1982. Kiln shelves collapsed, temperature distribution in the kiln was uneven. If I left the kiln for a short period the temperature dropped or rose alarmingly without apparent cause.

At my wits' end, I told my troubles to Amy. She asked if I had considered when I loaded the kiln. I had not; how I loaded it was a matter of constant concern, but when? What had that to do with anything? Yet by this time I knew that Amy never asked idle questions, but it was plain that she would offer no more help until I had attempted to think the matter through.

I was aware that the number three had great significance in Amy's tradition. Using my pendulum, I asked my guarding and guiding spirits if I should load my kiln on a date divisible by three. Yes, came the answer. Should I fire on any particular date? No, any date would do. Should I begin firing at any particular time of day? Yes. I whittled this down to an instruction that I must begin firing during an hour divisible by three, i.e. the third, sixth, ninth hour etc.

During the summer months in Tasmania clocks are put forward one hour, for what is called Daylight Saving. In Britain it is known as Summer Time. I asked if firing should begin according to the time by the sun. No, came the answer.

"Seems logical," said Amy when I told her. "Damned if it does to me," I replied. I failed to understand any of this. In the first place our calendar is a man-made contrivance, so what can be sacrosanct about a particular date? Amy said that what was important was that the date and times we have are those by which we regulate our affairs, and that this was the significant point.

I failed to understand this, but my guides 'told' me that there was one more thing I had to do. This was that, before beginning a glost or glaze firing, I was to mix a little honey in a glass of water and pour it onto the ground, saying to the Earth Mother, Hera, "Mother, in firing my kiln, I mean no harm to the earth. Please give your blessing to my firing."

And from that time on my firings have gone well. Naturally they are not all perfect, but they are as good as a potter might reasonably expect.

Pots Stacked for Kiln
Waiting to be unloaded; a successful firing of my ceramic fibre lined kiln.
Labyrinths and penguins decorate pots for specific customers.

All the above applies only to the glost firing, which is the second and final firing. The first, lower temperature firing, which hardens the ware sufficiently for it to be glazed, is called the bisque or biscuit firing. I was given no strange rules for that. Other potters load their kilns and fire when they wish. Why cannot I? All Amy would say, was, "You are not other potters." I try to rationalise in this matter. It was necessary for me to be made to question all my assumptions concerning the nature of our being and the structure of the ways things are. What we take to be logical and reasonable may be otherwise in the world behind the mirror. When Amy stopped the rain or waved that wooden beam, these things were not done through the exercise of the patterns of thought we have built up in our western centuries. When I am helped in

painting by positioning myself on a ley, it is this other mode of being that empowers me. So it was for the man who grew forty pumpkins on one vine. This is the world we have lost, along with the memory of Atlantis, but it is always there, waiting for us to find it.

Before one firing I forgot to ask for Hera's blessing. Disaster.

Many years later, I had a quite different problem. I was in the middle of a glost firing, when my digital pyrometer malfunctioned. It had never given accurate temperature readings, but I found it indispensable for telling me immediately if the atmospheric temperature inside the kiln was rising or falling. I had beside this instrument a pyrometer with a needle which moved across the temperature scale, but this, though much more accurate, would take some time to record a rise or drop.

There are three forms of control on my gas fired kiln, as on most others, the taps controlling the gas flow to each burner, the gas pressure gauge and the damper, which regulates the flow of exhaust gasses to the chimney. Towards the end of a firing, when the temperature is nearing 1300C, I had always found difficulty in finding the right balance between the adjustment of these controls, wasting time and precious gas.

When the digital pyrometer failed, with nonsensical numbers running up and down the scale, my first thought was to change the battery, but this made no difference. I considered aborting the firing, but realised that the glazes would be partly melted, and in cooling would probably bead, leaving bare patches on the surface of the pots, ruining them.

A short while previously, I had made a pendulum from a little ring of blue glass, an experiment in fusing glass in a ceramic mould. Since I liked to have a pendulum in my pocket, but did not wish to run the risk of losing the one Amy made for me, I asked, using the latter, if I would be able to have my questions answered with the glass pendulum. It appeared that I could.

In something of a straw grasping panic, I took the glass pendulum from my pocket and asked if I could be guided in my firing. Yes, came the reply. I was given the gas tap and damper openings and gas pressure. Every twenty minutes I checked these and soon realised that the temperature was rising evenly. The kiln reached the intended maximum temperature indicated by the bending of the pyrometric cone, seen through a spy hole in the door, without any of the usual problems. Next day, when the kiln was cool enough to open, I found that all the ware had fired perfectly.

That was only a few weeks before I added this account to my manuscript. Since then I have had one bisque firing and three more glost firings. All have been excellent in their results and quite trouble free. I don't feel any need for my digital pyrometer and am really quite grateful for its failure. The saving in gas has been considerable also.

For the benefit of any readers with knowledge of pottery, all the glost firings mentioned have been oxidised. I have not yet had cause to use the pendulum for a reduction firing. That should prove interesting.

I do not know if there is any direct connection between my pottery kiln firing and the location of the kiln within the environment of my garden, with the stones, the spiral and the convergence of several leys. In some sense all things are connected, when they relate in any way to these ancient, yet timeless things.

There is something more that leads back to that first stone I set, at the centre of a spiral. Amy told me that in the polar regions, there are holes in the earth's surface, into which the

pressure of the ice forces melt water. This water, she said, flows through channels deep within the earth, rising spirally, though not usually to the surface. When they do reach the surface, they are seen as thermal springs. These spirals are beneath the grid points, the points of power. My first standing stone is above one of these points. That is why I can detect a spiral centred upon it. When I set stones in the garden to restore the functioning of leys, the power focused by the first stone is channelled by the others to where it is needed.

I have explained how I use a dowsing rod in placing my other stones, but for many years I could only dowse with my pendulum. However much I attempted to use a rod, whether a forked stick or bent wire, nothing happened. One warm sunny afternoon, I was driving home along the road which follows the coast, feeling relaxed and content, because I had sold a quantity of pottery to a shop. My mood was complemented by listening to the wonderfully warm music of the Brahms Double Concerto on my car radio. Suddenly I knew I could dowse with a rod. It was certain knowledge. As soon as I had parked in my driveway, I walked over to the willow tree and selected a forked twig, trimming it to a suitable size. It pulled down over my first stone. Later I took to using a length of wire coat hanger, suitably bent, because willow twigs dry and become brittle.

A little more about the uses I have found for dowsing.

For many years I suffered from colds. Colds for many people are simply a minor nuisance, but they made me feel quite ill, necessitating time away from work. My wife was interested in the medicinal use of herbs, so I wondered if there was anything I could use to relieve cold symptoms. Using my pendulum I asked about all the herbs available in our kitchen. None it appeared would be of any use to me, so I began to ask about plants in the garden. I was directed to a patch of the native wild violet, growing beneath my son's bedroom window. I was to take three of the small leaves and divide each into three parts, placing one third part of each leaf, torn up, into a cup or teapot and pour boiling water on it. It was to be left for three minutes, strained off the leaves and drunk. At the first hint of a cold I took violet leaf tea, several times for a couple of days. All sign of a cold disappeared.

This works for me but not for everyone, though it relieved my daughter-in-law's asthma attack quite dramatically.

Years ago, at a picnic area in New South Wales, I was bitten by an insect, with resultant itching. Since I had no medication in the car, I used my pendulum to ask if there was a plant in the area whose leaves would ease the irritation when rubbed onto the affected area. I was guided to a plant, one quite unknown to me, which I used, to the complete relief of the itching.

Much more recently I was with my family near the dramatic Leven Canyon in North West Tasmania. In the warm sunny weather, after walking up to the lookout, we sought a shady place to sit reading and drinking tea. Unfortunately the 'mossies' approved our choice of location and I was bitten several times on my right ankle. I took my revenge by swatting one, but this did nothing to relieve the growing itch. I found the tube of anti-itch cream in the car's glove compartment completely dried up. Remembering the long ago incident in New South Wales, and having a pendulum in my pocket, I again asked if there was a plant in the vicinity I could use. It appeared that the soft brown unfolding tips of bracken were indicated. I collected a few small bits and rubbed them on my ankle. Immediately the itching stopped and did not return.

CHAPTER 6

A repository of ancient knowledge in Tasmania.

The main north-south route linking Tasmania's capital city, Hobart, with Launceston, the major city in the north, is the Midland Highway. It runs rather to the east of a central north-south line, avoiding the Central Highlands, a lake strewn plateau, in places, four thousand feet high in the old measurements, which seem to be favoured in this tradition. Some lakes are natural, others artificial. It is an area of hydroelectric workings, fishermen, holiday shacks, enormous trout, tree felling, wanton slaughter of wildlife, and earth roads. I avoid it, as does the Midland Highway.

This was originally a coaching road, complete with highwaymen, here called bushrangers. About midway, the village of Ross was built as a staging post. Today the highway bypasses Ross, left dreaming beside the Macquarie River. It is a pleasant place to break a journey, to stretch one's legs and take refreshments at the pub or the several cafes. Many of the original sandstone buildings from the convict era survive, in their restrained Georgian style. Flowing through quiet meads, its banks lined with elms and willows, with hawthorn and rowans nearby, the river divides into three below the arches of a handsome and dignified sandstone bridge.

The coach road from the south ran over this bridge on its way to Launceston, which is situated at the point where the South Esk and North Esk rivers empty into the great Tamar River, a magnificent tidal estuary, in whose valley fruit is grown, wines and cheeses are made and artist craftsmen and women have made their homes. The stone bridge at Ross replaced a wooden structure which was several times washed away during the winter floods. John Lee Archer, the able government architect, designed this noble structure, and a gang of convicts with military escort was sent up from Hobart to build it. Among these convicts were two competent masons, who were set to supervise the work. They were James Colbeck and Daniel Herbert.

Just outside the village the quarry from which the stone was taken may still be seen. The building took eighteen months and the bridge was opened by Lieutenant Governor Arthur in 1833. For their work both Colbeck and Herbert were awarded their freedom, and their descendants' names may be found today in the telephone directories. Daniel Herbert, who most concerns us, stayed on to live in Ross as a respected stonemason.

Before I came to this island state of Australia, I saw photographs of Ross Bridge, and noted that all the arch stones were enriched with carvings. The bridge appeared too distant to see them as more than a rich texture. Soon after we came here, on a visit to Hobart, we turned off the highway to look at Ross Bridge. I was awed by the strangeness and power of the carvings. There were heads of men, women and beasts, some wearing crowns. Plant forms, animals and apparently abstract shapes mingled in a rich riot. As sculpture they related to nothing I knew, and I was well acquainted with sculpture from most of the world's cultures. In spite of this riot of forms, there was a timeless quality about these stones. They took hold of my imagination.

I found a book about the Ross Bridge sculptures, remaindered in a Hobart bookshop. The authors had sought to relate them to ancient Celtic art, for the only thing that Daniel Herbert

is recorded as saying about his carvings is that they are Celtic. I found the comparisons made between the Ross sculpture and historical work very unconvincing, as I did the no doubt scholarly attempt at psychological analysis. Even less helpful was the comment in another book, calling the carvings the rebellious ravings of convict scamps. How can people be so totally lacking in perception?

Ross Bridge, Tasmania

The book I bought contained some fine, large sepia photographs, showing carvings in close up. As I studied these I became convinced that they related to the things Amy was teaching me. I showed her the book and asked her if this was so. "I wondered when you would realise that," she said. As she usually did with such things, Amy set me the task of trying to work out the meanings for myself. With some of my interpretations Amy agreed. Sometimes she would add something or ask me if I had considered such and such. Just occasionally she would tell me something outright. To many of my questions, I would hear the all too familiar reply, "You are not ready for that yet," or "I'm sorry, I cannot answer that." Even so intuition, or guided thought, coupled with the use of my pendulum, took me a long way, though there is still much I have not found the keys to unlock.

One stone showed five concave sided diamonds in the form of a quincunx, the central diamond being larger. Below this formation was a spiral above a shape resembling an ear or shell. As we looked at the photograph, Amy pointed to something which she said was a mask. I could not and still cannot see it, but from what follows I am certain that Amy was right.

The mask, Amy said, meant—'Look for that which is hidden.' The curved shape meant—'Be still and listen, for I speak.' She told me this much, for I would never have got that unaided. Obviously this stone would require much thought. We have seen that diamonds can mean something precious within the earth or to do with the earth. For a time this puzzled me, but eventually something made me think of a group of hills some distance south of Ross, near where the highway begins its rise to the bleak uplands, which eventually dip down to the southern region around Hobart.

What drew my attention to these hills was that one appears from the road to be an almost regular cone, whilst another looks stepped, like an eroded Mesopotamian ziggurat. Just as I had a feeling about Ross Bridge, so I had about these hills, and there were five in the group, as there were five diamonds on the stone.

Some miles to the east the map's contours showed another conical hill. What would I find if I ruled a line from one conical hill to the other and extended the line? I found nothing. From the spot height marks on the other hills in the group, nothing was obvious. One hill, of rather amorphous shape was left. It seemed an unlikely prospect, but I remembered, 'Look for that which is hidden.' With this hill I struck gold. The line from its spot height to the second cone went straight to the Devil's Whirlpool, in a river, which was on the path of the ley which cut through Amy's garden.

So Daniel Herbert knew of this location and I infer that he knew of the Ley of the Waters. Some day I may discover why he was at such pains to draw attention to it, however covertly.

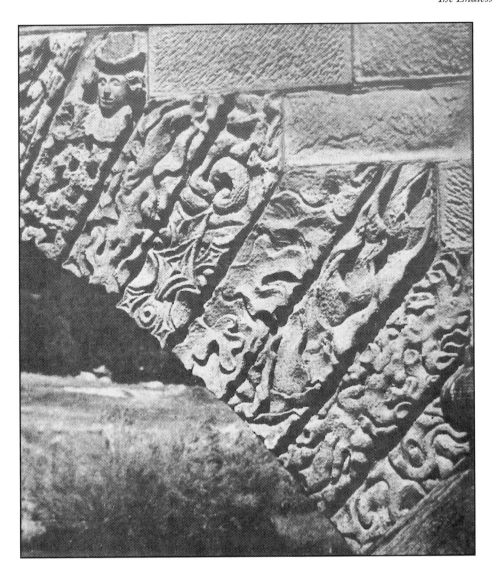

Ross Bridge Detail

The knowledge was kept by three families in Cornwall. According to Amy, hers was the principal family, holding rather more knowledge than the other two. Daniel Herbert was descended from one of the others. Amy said that in her family The Words were passed down through the female line. That does not mean that the menfolk knew nothing. Amy's chartered accountant father knew a great deal, as did her maternal grandfather who was, like Daniel Herbert, a stonemason. Her husband, who was also her cousin, did likewise. Daniel Herbert knew a great deal.

It is said in The Words that no person travels unless it is so ordained. That referred to people who were in some way connected with the matters I am writing about. Daniel Herbert was intended to come to Tasmania to fulfil a task, though he came in chains. He was destined to come to Ross to make a lasting monument, a document in stone, which was to be a message to a future time, when it would be understood. That time has come, now that our eyes and minds are opening a little.

In 1836 the meaning had to be disguised. How could Daniel Herbert have explained to church and state authorities his belief in reincarnation and the ancient gods of Atlantis, or theories about cycles of time? As much as that page from the Book of Kells, Ross Bridge is an encoded statement. Let us look at more of its symbols.

Lieutenant Governor Arthur, the supreme authority in the infant colony, who opened the bridge, looks over the flowing river from his carved portrait. Below him on the same stone is a skull, somewhat disguised, but unmistakeable, when pointed out. What would the colony's governor have made of that? Governor Arthur doubles as Até, the Evil One, who embodies the righteous virtues of oppression in the name of law, and of belief in one's own great worthiness, coupled with contempt for those less fortunate than oneself. Até's servants do not break the law, though they may bend it in their own interests. Indeed, they may represent the law, the Church or great business corporations. The skull makes its comment and needs no explanation.

A puppy's head appears on another stone. On its forehead is an incised circle, flanked by curved lines extending sideways, a sunset. The puppy is a symbol of youth, of beginning, the sunset a symbol of ending. This is a representation of the cycles of time we have already encountered, in which man begins in a very primitive state, then learning to build cultures and civilisations, until he gains the material knowledge, without matching wisdom, that enables him once more to destroy much of the life of Planet Earth.

Twice more the cycles of time are depicted on Ross Bridge. On one stone they are seen as the Phoenix. We will look at this in context later. The other representation is on the keystone of the eastern arch on the bridge's southern face. It takes the form of a crowned head, part human, part beast, and full of the pathos of old age. He is Cronos, god of time. Beneath the head is a distorted ring, representing the cycles of birth and destruction. It is distorted because the cycles are not of precisely fixed duration. Some indeed continue, avoiding destruction, when mankind achieves wisdom and balance, as it did for so long in Atlantis. Later, we will see a symbol of that balance.

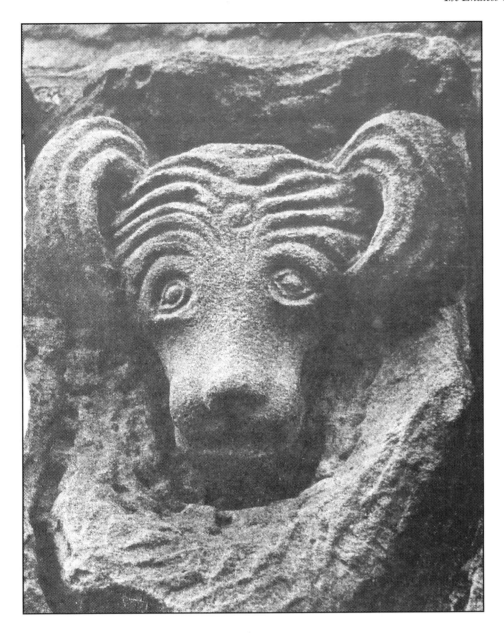

Ross Bridge Detail

Flanking the keystone are sheaves of wheat. These are the cycle's harvest of souls having no need of further earthly journeys. Time and the earth have not been wasted. They are a stage, upon which men and women play their parts, some learning in the process, for the world is also a nursery, school and university. Cycles are necessary, for when things become too complex, when our cleverness destroys too much, a curtain comes down and the stage is cleared, so that a new act may begin. These symbols in stone are the visual equivalents of aspects of The Words.

Another keystone bears the head of a water rat or water vole. He wears a crown topped with a cross. Two fleurs-de-lis flank another cross on the body of the crown. Hair flows down from the head, curling into spirals. Between the paws at the base of the stone is a round form, the earth, and the water vole is the God of Water. Once we realise this we see the flowing

hair as water giving life to all things that grow, but the spirals are those at the points of power in the grid. The fleurs-de-lis, apart from being traditional symbols of royalty, serve the same function as the plant forms in the Book of Kells. They represent life, life which came to Earth from elsewhere.

There is more. Both crosses on the crown are basically Maltese crosses. This form is a symbol of communication, for which two things were needed, apart from a standing stone and knowledge. They were a water spiral and electromagnetism. Many forms of rock contain crystals of silica, in which piezo-electric phenomena may occur. This is part of the story, but I do not pretend to know how these things worked together to produce an instantaneous, universal means of communication. I am certain that Amy knew, but she was not permitted to tell me. A trinity of gods represent communication. They are The Thunderer (electromagnetism), The Messenger and The Water God.

A cloud form descends over the upper part of the earth form, between the Water God's paws, symbolising rain, to fertilise the earth. On the stones flanking this keystone are plant forms, suggesting fruit, and the growth of all life forms made possible by water.

A ferocious beast presses down a large paw upon the head of a smaller, gentle looking animal on another keystone. The beast has a crown, surmounted by a cross. This symbol represents the Christian churches suppressing the old knowledge. It gives point to the secrecy in which the knowledge was kept and transmitted.

Some stones are meant to be seen as a group or read in sequence. One such group includes both the Governor Arthur/Até stone and the stone with the quincunx of diamonds. The lowest stone, on the right, shows tumbling human figures. They are falling to a lower spiritual level, because they have not done well in their last incarnation, having learnt little or nothing of spiritual value. On the stone above in this series, one figure stands upright, whilst another lolls horizontally, resting upon one elbow with its hand supporting its chin. They are people in the midst of life, one making the effort to stand up, to learn and to take responsibility for his self. The lounger will later become one of the tumbling people.

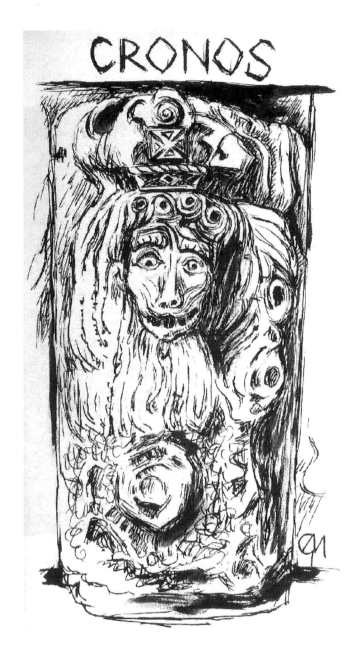

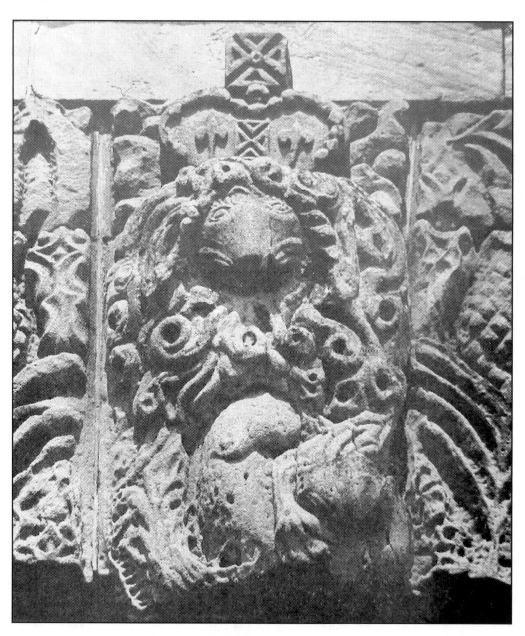

Ross Bridge Detail

Ross Bridge Detail

The third stone is all rising wings, symbolising the aspiration of the awakened spirit. The next, moving up the arch, shows progressively more abstract renderings of a leaf, representing a succession of realms above the material. We have examined one aspect of the next stone, the one with the five diamonds. It occurs in this position in sequence however, because an aspirant to spiritual knowledge must learn of the forces associated with it within the earth, of which there are five. These are the leys, the points of power, channels of communication, the electromagnetic qualities of quartz in rocks and, represented this time by the largest symbol, the life force . . .

Above this stone is one bearing three symbols. The left hand edge is carved with the profile face of a bearded man, rather flattened to maintain the line of the stone's edge. Some people find this difficult to see. I recommend letting the mind relax and looking at it for some minutes

and if it is not seen then, come back to it another time. Immediately behind the profile, and rising higher, is a dragon, though rather a slug-like form. Below this is a creature with a broken neck. As in the Book of Kells, the dragon is a symbol of spiritual matters and forces, and therefore of wisdom. Thus in the head of the wise man, spiritual knowledge ascends. He has subdued the baser qualities within himself, with the help of Pan and his spirit guides; hence the second creature's broken neck.

The Até representation, occurring next in the series, is a warning against pride in one's knowledge and achievements, and also against having contempt for those who have not progressed so far.

Daniel Herbert carved his self-portrait mask at the head of a stone, surrounded by emblems of his knowledge. On the same stone are plant forms, symbolic of the natural world, and his knowledge of its essential nature. Two stones to the right, a succession of overlapping forms are the generations of both animals and people. Left of this, another aspect of life is depicted in a winding line that continually overlaps itself. This is reincarnation. As in the Book of Kells, it is the journey of our spirits into and out of this life, and life on the other side of physical death. Here the spirit rises until it achieves a proper balance, represented by the twin ogee shapes, as it did for many on Atlantis and Mu, before greed and lust for power brought about their destruction.

To the left of Daniel Herbert's mask is a stone with two creatures carved on it, one rising and one falling. Once more the rising form is the dragon, symbolising the powerful and beneficent forces within the earth and from the galaxy, knowledge of which enables the spirit to grow and develop. The other form, with the foolish, beaked head and wide female hips, represents sensuality, having the opposite effect.

So all these things are a part of Daniel Herbert's knowledge, which he carved in stone to be read in our time, when some may understand. They are not simply remembrances of things past.

Two and a half rose-like forms occupy all the space on a stone, yet these are not flowers. We have already seen one of them in miniature on an ogee shape, where it represented Atlantis. It does so here, in the one with the small upright cross in its centre. The other stands for Mu, and the part shape at the top symbolises the Lost Lands, sometimes called Lyonesse, which once extended into the Atlantic Ocean from Cornwall. Of these lands only the Scilly Isles remain. They sank much later than the two continents.

Ross Bridge Detail

Ross Bridge Detail:
Crescent moon—the symbol of change next to symbol of Atlantis.

When Atlantis sank, the world changed.

Let me explain the symbols. What appear to be the rims of petals are the great waves, or walls of water, rushing in to overwhelm the land, as are the narrow forms which press into the indentations between the petal-like shapes. In the centre of Atlantis, the upper 'rose', is a circle with scalloped edges, meaning that the waters came thus far and no further. Within the circle is a raised mound, cut through with a cross. The mound is the Holy Mountain. Plato wrote that, upon the Holy Mountain, there were springs of both warm and cold water. He also wrote that rivers flowed from the mountain to the north, south, east and west, symbolised by the cross. What remains of the Holy Mountain is the island of Sao Miguel, in the Azores. "Going home, wasn't I," Amy had said to me.

As far as I can ascertain, the cross in the centre of the Mu 'rose', is there simply to complete the decorative scheme. The rose form given to the Atlantis and Mu symbols puzzled me for a long time. Then I remembered that Amy had told me that the asteroid, which eventually fell to destroy these continents, came to circle Planet Earth in 'the month of the roses', as June is called in The Words, though of course this was five thousand years before the asteroid fell in 9631 BC. Atlantis did not disappear immediately, as Plato said. It spilt into two islands, but this was the beginning of profound earth movements, which saw the Sinking completed within fifty years.

To the right of the Atlantis stone is a portrait of Daniel Herbert's wife. Below her is a moth. As in the Book of Kells, it is the symbol of the spirit, but here in a different role. It faces downward, and is adjacent to the Atlantis and Mu symbols, meaning that for some time before the Sinking, the true spirit had departed from these lands.

Left of the Atlantis and Mu symbols, the stone shows the mask of a bearded man with a crescent moon upon his head, the moon being symbolic of the cycles. He represents change and the dawning of a new age. Below this mask are chaotic forms, representing the world immediately following the change.

The Phoenix is on one of a fascinating pair of stones. The stone to the left represents the choice so often presented to individuals, groups and nations, between peace and strife. In the lower left-hand corner is a serpent, and ancient symbol of wisdom, but its head points down, and its tail holds aloft a bunch of grapes. These are the grapes of wrath, and the serpent of wisdom is stood on its head. In contrast, two overlapping doves, symbols of peace, fly heavenwards. About a third of the way from the bottom, against the right-hand edge, is the head of an imp, representing the choice that is always before us between right and wrong, conflict or harmony.

Here I must divert a little to consider a further statement Amy made concerning choice. When a person selects one course of action, rather than another, the other possible course is followed by another aspect of our selves. Amy always insisted that the universe is infinitely more complex than we believe, or experience it to be. She spoke, as of course others have also done, about parallel universes. Perhaps inter-penetrating might be nearer the mark, or co-existing.

Ross Bridge Detail

This compounds the meaning, for which I gave a simplified explanation, of the mirror image component, within the arms of the X figure in the Book of Kells. It brings into consideration the nature of matter, space and time. I have said that Amy's tradition states that teachers went to India, and to all inhabited places, bringing knowledge of Atlantean beliefs; also that the Lord Buddha was an incarnation of Pan.

Buddhists speak of the world of matter, space and time as an illusion (dharma). Science tells us that what appears to us as solid matter consists of particles of energy, continually in motion, separated by, on this scale, vast space.

Within atoms, electrons appear and disappear in regular cycles. Where do they go when they disappear? Do they help to build the material of a universe interpenetrating our own? But the idea of aspects of the self, continually branching off, implies an infinity of universes.

Then is time, as we experience it sequentially, an illusion of our corporeal state? We are not equipped to contemplate all events as being subsumed into an eternal now.

Yet, if I read Amy's beliefs rightly, I do not believe she considered our experiential world to be only an illusion, but rather an aspect of a much greater whole, necessary for the evolution of the spirit.

One more thing: Amy insisted that all atomic and nuclear explosions are wrong, because they destroy what she called the 'between worlds'. She did not elaborate on this, but I think the explanation must lie in what has just been discussed.

At the base of the other stone is a recumbent human figure. Rising from it is a much expanded form, the spirit, with its head beneath the body of a gryphon. Part beast, part bird, the gryphon symbolises the dual nature of man, the spiritual and the earthbound. The Phoenix above represents reincarnation, since legend says that periodically it is consumed by fire, later rising from its ashes.

This stone is very rich in symbolism, for the gryphon also tells us that what occurs on Earth is known elsewhere, that our spiritual progress is recorded. All is related to our choosing, the choice shown so graphically on the other stone. The Phoenix also symbolises the recurring cycles, and that mankind's situation continues the same, whenever and wherever incarnation occurs.

The more we study these stones, the more we perceive the depth and extent of Daniel Herbert's genius that could compress such wealth of meaning into so few visual terms. Not only that though, for he was forced by the circumstance of his time and place to draw a cloak of obscurity over his work to deflect uncomfortable questions from his contemporaries. How, one wonders, was his work viewed by the architect? What, if anything, did Lt. Governor Arthur make of it? How much was Captain William Turner of the 50th Queen's Own Regiment of Foot, a party to Daniel Herbert's thoughts. It is known that this soldier held him in high regard, showing respect, even friendship, which must have been an extreme rarity between a serving officer and a convict. I suspect that those in authority were simply pleased that the arch stones had been given some form of decoration and did not enquire over much about any intention behind it. If enquiries were made, I feel sure that Daniel Herbert was able to deflect them with harmless, if spurious, explanations.

Ross Bridge Detail

As I have indicated, Amy was only prepared to discuss the meaning of certain stones. There is a great deal on Ross Bridge that I have not been able to explore, but there are yet two more stones that allude to the time cycles. The image to the left resembles the contents of a sack of potatoes tumbling down. It represents earth changes covering all trace of the former world order.

On the north facade, above the central arch, the parapet thickens out with a great slab of stone, on which is inscribed, COLONEL GEORGE ARTHUR, LIEVTENANT GOVERNOR. Below this is the keystone, on which are carved symbols of industry and military power, surmounted by a form of crown. On the surface, all this seems appropriate for its position. The irony lies in the face of the bird below. In a book I read this is described as the head of an owl, which seems to have little relevance here. It is in fact a vulture. In the

century following that in which Daniel Herbert lived, we have seen enough of militarism, backed by industrial might, for the symbolism to need no explanation. All this beneath the proud name of the soldier-governor. The unusual crown is itself crowned by swirling forms, the fumes of industry and war. Trees flank the keystone, growing things, the life of the Earth which war and uncontrolled industry destroy.

Jorgen Jorgenson was a Dane, who had served in the British Navy. At another point in his adventurous career, he had led the bloodless revolt in Iceland against the Danish crown, and had for a time ruled the country, until a proper constitution could be formulated. He arrived in Van Diemens Land as a convicted felon, having fallen foul of the law in Britain, yet came to Ross in charge of a police party. His life at Ross was rather tempestuous as he attempted to fight corruption.

Jorgenson's mask shows him wearing a crown. His wife, Norah Cobbett, an Irish woman with a drink problem, is depicted with a most woebegone expression. Daniel Herbert has used these masks to illustrate two sayings, 'He who ventures may win a crown', and 'They who dare not win but regret'.

I know only a little more. Over the intervening years, I still hear Amy's voice saying, "I'm sorry, you're not ready for that yet," so the bridge still keeps many secrets. Who will read them?

It may seem that the Ross Bridge carvings are laden with messages of doom, but we must see them in the larger context of reincarnation and the eternal life of the spirit. Ross Bridge may not exhibit the extremes of refined skill so evident in the Book of Kells, yet the carvings have a grandeur, a power and a compelling mystery. Their iconography is unique, and Daniel Herbert created a sculptural form without precedent in the history of art. His sculptures are a fitting complement to the Book of Kells, yet, while the book's fame is spread worldwide, beyond Tasmania's shores, Ross Bridge is scarcely known. This deserves to change.

Ross Bridge Detail

Ross Bridge Detail

Ross River Bridge Detail

CHAPTER 7

The Gateway to the Sun, Atlantis and the other gods.

On one of my many visits to Amy, I showed her an illustration of the central carving on the so-called Gateway of the Sun, at Tiahuanaco, on the Bolivian Antiplano, near Lake Titicaca. "Ah," she said, "That was made by my people." "Surely not by the Celts," I responded. "Long before any of us were called by that name," was her reply.

Since history and archaeology rightly show that the Celts came westward from the Danube region, we must remind ourselves of Amy's beliefs, that before the Sinking, those people of Atlantis who had kept faith with the old ways and beliefs, and had not given way to greed and lust for power, slipped away from Atlantis. Some went to South America, some to Africa, while others went to Britain via Lyonesse. Most of the last group crossed the then existing land bridge to Europe and settled in the Danube Valley. During the millennia of their sojourn there, their culture was eroded through contact with primitive peoples. Also, because the Atlanteans had abused their knowledge, their descendents in Europe were forbidden to employ the old forms of power and manipulation of forces and materials, which needed the co-operation of man, the spirits and the gods. Undoubtedly, to most people in our time and in our western civilisation, this is nonsense. Years ago it would have been to me, but then I experienced that problem with firing my kiln and was told the cure for it. It was a painful but essential lesson.

The Knowledge from Atlantis was not entirely lost, for it was given to certain families to keep. Much has been made of the Druids, but they only had a portion of the knowledge. Their initial function was to keep the people together. Unfortunately, like most priesthoods, eventually they sought power over the people, and this became more important to them than retaining their apportioned part of the knowledge. Let me say here, quite unequivocally, that those who today call themselves Druids know nothing. They delude others and are self-deluding. I am not of course referring to the Welsh gentlemen, who so ably preside over Eisteddfods. They are the invention of Queen Victoria's German Prince Consort, Albert.

Amy said that the people, eventually known to history as the Celts, migrated westward, feeling the call of their mother ocean. Following the fall of the Roman Empire, waves of migrating peoples finally pushed the Celts into the western extremities of Europe, including Cornwall. But not all the Atlantean people had originally moved into continental Europe, and the knowledge never left Cornwall. Some in Ireland also retained it.

The Gateway of the Sun was made by Atlanteans, "My people," Amy said, but it was placed in its present position long before the Sinking, having been taken from a temple in Atlantis, before it could be drowned when the tide was raised by the asteroid. We will examine the central figure above the door opening.

I asked Amy if this figure represents Pan. It is, she said, both Pan and Man. Pan, The Great One, Amy called him, sometimes here called Viracocha, Quetzalcoatl and other names, but always the same Sky God. But this figure has a dual identity as both the god and man. In either hand the figure grips long forms with bird heads, extending above and below the hands. "They represent the world," Amy said. I asked her if the hands divide the world at the Equator. She agreed that this was correct. I pointed out that the upper and lower parts did not

match. Amy replied that the hemispheres of the Earth are not identical either. That puzzled me until I realised that she was referring to the unequal distribution of the landmasses.

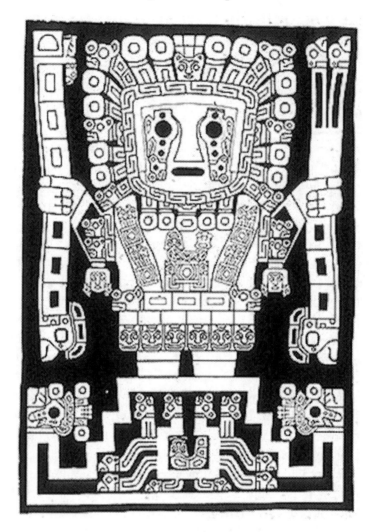

The Gateway of the Sun

So here, as in the Book of Kells is an awareness of the Equator and the hemispheres. In the figure's left hand, the upper section is divided. One part represents the linked landmasses of Eurasia and Africa, the other the North American continent. The three rectangles in the lower part of the form symbolise South America, Australia and Antarctica.

In the right hand are the oceans. These cannot be divided between the hemispheres as the continents may roughly be divided, but above the hand are the Arctic, North Atlantic and Pacific oceans. Below the hand are the South Atlantic, the Indian and the Southern oceans, all represented as rectangles. Both Man and Pan have responsibility for the earth.

Above the feet is a row of six faces. According to Amy, the Atlanteans believed that Homo sapiens did not evolve from Neanderthal man, Homo erectus or any of the proto-human forms found in the fossil record, but was brought to Earth in the space-time ships, the 'vehicles'. It was said that human beings came from two planets within the solar system and from four others much farther away, matching these faces in number.

There are two symbolic heads above the navel. The one to the left is inverted, looking upward; the other looks out towards the observer. Looking upward represents man's desire for spiritual knowledge, looking outward symbolises the desire to explore the material world. The concentric circles of the navel represent Atlantis, where both spiritual and material understanding was sought.

Upon either side of the navel and these two heads there are curved bands. At the top of each of them is a pair of bird heads, facing upward. Below, and a little separated from them, are two lizard heads. The bird heads represent human spirits which, during an incarnation, take the opportunity to learn and develop. Those which do not are the ground hugging lizard heads. In each case the heads are in equal pairs, male and female. This is a variation on the message we have seen on Ross Bridge, separated from this carving by so many thousand years.

Surrounding the head of the figure is a chain-like band, in form resembling the 'Greek-Key' pattern. This, Amy told me represents the Sun. I objected that its continuity suggests everlasting life. She said that so did the Sun. So this refers to the everlasting life of man and the Lord Pan. Perversely, unable to let things go, I once more objected that science appears to show that the Sun, like all the stars, has a finite life. "Nevertheless," Amy continued, "we believe that the Sun goes on for ever." I don't pretend to understand this, but from experience of Amy, I can quite believe that there is some quite unexpected explanation for that statement. Doubtless I was not ready for it.

The figure stands on a typical American stepped pyramid. Pan was said to descend to Earth in human form in one of the vehicles. Originally, it was said, such pyramids were landing places, as were the ziggurats of Mesopotamia.

Although the iconography is different, the final part we examine parallels symbolism in the Book of Kells. Within the stepped pyramid's base there is a square, containing a chrysalis. From this square animal forms radiate in many directions, symbolising life throughout the universe.

As with other works we have looked at, there is much more in the scheme that I know nothing about, except that I strongly suspect some of the heads of being representations of Yogi Bear and Booboo!

I recorded Amy having said that the Gateway of the Sun was taken from a temple in Atlantis. (Amy told me more than once that the stepped cross, representing a Sky God, below the P-J symbol, in the Book of Kells, was also the plan of the temple at Tiahuanaco.) It was, she said, incorporated into a new temple at Tiahuanaco, before the asteroid raised tides, flooding the original temple.

> This is from The Words.
>
> And came the Star, and drove Mighty Earth from her course. Strong men wept, and women suckled not their babes, for fear of the darkness. Mountains heaved, rocks fell from the sky and the plains split asunder. Fire slew the giants of the forest and destroyed the food of the people, and there was no joy on Earth for many moons.
>
> There is a remarkably similar passage in the Mayan book, the Popal Vu.
>
> This happened when the Earth began to awake. Nobody knew what was to come. A fiery rain fell, rocks and trees crashed to the ground. He smashed trees and rocks asunder . . . And the Great Snake was torn from the sky . . . and its

arrows struck orphans and old men, widowers and widows who were alive, yet did not have the strength to live. And they were buried on the sandy seashore. Then the waters rose in a terrible flood. And with the Great Snake the sky fell in and the dry land sank into the sea.

Do we then have accounts of the same event, from opposing shores of the Atlantic Ocean, from Cornwall and from Mexico? The account in The Words is brief, factual and intensely vivid. As in all things in The Words there is nothing mythical or metaphorical in the expression. Because it was held in secret by its keepers there was no need to obscure its meaning. The Mayan is less concise and uses more primitive imagery. It was Amy's opinion that this was deliberate, a kind of concealment.

So the asteroid came with great destruction and began its five thousand years aloft as a satellite of Earth.

The German rocket engineer and inventor, Otto Muck, was a colleague of Werner von Braun, who worked on the German V2 rocket, and later in America, for NASA. He believed that there had been a continent of Atlantis in the Atlantic Ocean, and that it had been destroyed by a rogue asteroid, which had departed from its usual orbit within the asteroid belt. It approached Earth, he said, circling around her three times. On the second revolution it came low enough for friction with the atmosphere to heat it to such an extent that its outer casing disintegrated, showering the eastern seaboard of North America around what is now the coast of the Carolinas, causing the indentations known as the Carolina Bays. Coming yet lower, on its next passage the core split in two. One half plunged into the Gulf of Mexico, making an enormous crater, which is still a deep hollow in the seabed. The second piece hit Atlantis, just west of the chain of volcanic mountains, remaining now as the Mid Atlantic Ridge. Violent volcanic and earthquake activity followed, causing enormous tidal waves, spreading over the land, which sank amid the turbulence.

The account in The Words is essentially the same, but for one thing. It says that the 'star' came, with all the disturbance and tribulation in the passage quoted earlier, but that after erratically circling the earth, crisscrossing the sky in many directions, it finally assumed a stationary orbit over Atlantis. Its enormous gravitational pull raised a great tide, drowning the equatorial regions of Atlantis and South America. The water, which fed this tide, was drawn from the North and South Atlantic Oceans. So high was the water raised that parts of the ocean bed to north and south were drained. The so-called Bimini Road, that submarine structure of cyclopean masonry off the coast of the island of Bimini in the Bahamas, was constructed as a sea wall, at the edge of the great tide. At the water's higher extreme, over the millennia of the tide's existence, marine beaches were formed near Lake Titicaca. The strandline slopes north to south, the northern extremity being 295 feet higher than the lake level, 400 miles further south it is 274 feet lower than the lake level. Since the region is south of the equator, this accords with the curvature of the raised flood mass of water. Tiahuanaco was then near the sea. Therefore it was the sea that came to the Andean heights, and the geologists' explanation that the Andes were suddenly raised to their great height in very recent times is false. Tiahuanaco was both a refuge and a port.

It is interesting to note that Professor Arthur Ponansky of the University of La Paz and Professor Muller date the main phase of construction of Tiahuanaco to 15000BC. Since The Words put the coming of the 'star' five thousand years before the Sinking, begun in 9631BC,

and that the city was built in preparation for the tides to be raised by the' star' five thousand years before the Sinking, it is plain that the professors' date and that in The Words coincide as nearly as may be.

The professors also state that the city suffered a major natural catastrophe in the eleventh millennium BC. Given the enormous time scale, 9631BC, in the tenth millennium BC, is pretty near the mark.

Evidence was also found of crop growing near Lake Titicaca. Today maize cannot be grown there and potatoes are stunted. It is said that this is owing to deterioration of the climate. If the crops were grown at near sea level, as it was then, the climatic deterioration is easily explained.

Machu Picchu was also originally an Atlantean city, though built over by later peoples. It is said that the Atlanteans had warning of the asteroid's approach, and had time to prepare these refuges in the high fastness of the Andes.

I recall reading a long time ago that French scientists, when diving in a bathysphere off the coast of Portugal, descended parallel to the undersea cliffs off the continental shelf. They were surprised to see flights of stairs cut into the rock face. These, Amy said, were made by Atlantean people, when the ocean was drained at that latitude.

The asteroid remained stationary, as a moon over Atlantis, for five thousand years, until it began its fateful descent, again circling Earth, in a descending orbit. Then it behaved exactly as Otto Muck, rocket engineer, inventor and ballistics expert, described. What triggered this descent I was not told, with the amount of almost over-whelming information that was coming to me I did not pause to ask. Now it is too late.

It was the year 9631 BC when this occurred. At that time the continent was split into two islands. These had sunk by about forty-seven years later. Perhaps this is where I should relate what Amy told me about Atlantis and its people.

In the open star cluster we call the Pleiades there is a planet, an ancient home of mankind. A civilisation developed there, far greater than our own, and with very different values. The Sky Gods, otherwise called the Great Ones, took people in metal ships, the space/time vehicles, to another planet, in the vicinity of the star, Aldebaran, the red eye of the bull in Taurus in the Hyades. This planet was called The Blue Star, because of the colour of its rocks, but it was also known as the Resting Place, for the people stayed there for a time. The flower symbol we have seen in the Book of Kells as a symbol of life throughout the universe is called the Lily of Aldebaran, for a lily was one of the life forms added to those the people had brought with them.

From the Resting Place they were conveyed to Planet Earth. Their name for Atlantis meant the Place of Landing. Atlantis was not uninhabited, for there were people there known as the Sea People, not to be confused with the much later people given that name who ravaged Egypt. The mingling of the two peoples created the Atlantean race.

When the people from the stars landed, they found themselves on a circular plain surrounded by a mountainous rim and with a mountain in the centre, the whole formation being an impact crater, such as we see on the moon. On the mountain were springs of hot and cold water. Four rivers ran down its slopes roughly to the cardinal points of the compass. Formalised, this formation is the origin of the Celtic cross, now forgotten by most as a symbol of the Celtic people's roots.

At one side the circular plain was near the sea. A channel was cut through the crater rim, from the sea toward the sacred mountain. Other channels were made, concentric with the rim, all joined by the straight channel. On this plain a city, the Sacred City was built. Its name was Numenor. J.R.R.Tolkein used this name in The Lord of the Rings for the lost land in the west. The name is also said to be that of the fabled city of the Celts, though I am unaware of the source of this belief.

I will divert a little here. Tolkein attended King Edwards Grammar School in Birmingham, founded by King Edward VI. I attended Queen Mary's Grammar School, Walsall, founded by Edward's sister, Mary Tudor. Our schools played each other at Rugby football and cricket.

It was during World War 2 that I started at Queen Mary's. Until the war it had enjoyed a good reputation, but when I supposedly began my studies, the younger masters were being called up into the armed services, to be replaced by the old, the unfit and women, most of whom had no experience of teaching boys.

I was far from being a model pupil. My aim was to have fun, mainly at the expense of the teachers. That I should eventually teach would have been a thought too ludicrous to contemplate. My problem was that much of what was taught bored me. It failed to answer any of the questions that troubled me; what are we, what is our purpose, are we more than chaff upon the wind?

In the Fourth Form, in a Religious Instruction lesson, The Beak, as the headmaster was known, posed the question, was it possible that there was no outward reality and that all we experience happens only within our own minds? I put up my hand and said that that was a theory of Descartes and Lock. He quickly went onto another topic. I had gained that bit of information from a BBC schools broadcast, when I had stayed home with a sore throat.

I liked art, although the teaching was singularly unimaginative, but my imagination came alive with Shakespeare, taught with love and insight by 'Swiney', so called for the quiet, deadly sarcasm, with which he controlled our unruly spirits.

Panic struck me in the penultimate term of the fifth year, for I had wasted so much time fooling around. There would be no school certificate for me. What would I do with the rest of my life? Surely it was far too late to mend my ways and catch up, yet I started to mug up on all the subjects I could to some extent understand. When the dreaded examinations arrived I resigned myself to my inevitable fate. That summer holiday was a hell of anticipation awaiting the letter bearing the dread results. It came. My parents opened it. Incredulously they read that, not only had I passed, but I had gained the best result in my class. It was a miracle I have never understood.

It would be an impertinence to attempt to draw many parallels between Tolkein and myself, but there in one, which is quite genuine. In his autobiography he says that from a vantage point (was it the Lickey Hills?) he could see the mountains of Wales, and he dreamed of an enchanted land to the west. For my part, I cycled to Barr Beacon, from where, on the edge of sight, I could see the long line and sharp fall of the Black Mountains. It was wartime and travel was severely restricted. Wales to me was a land of mystery away over the western border. Now that I have travelled many times through Wales, it still holds me in its spell.

Tolkein was as familiar as I was with the train journey from Birmingham's Snow Hill station to Wolverhampton. It was the sight of factories belching smoke from their tall brick stacks, the places left waste after shallow mining for coal, the heaps of slag from blast furnaces,

the foul pools and equally fouled canals near chemical works, giving off poisonous vapours; these horrific sights became his Mordor.

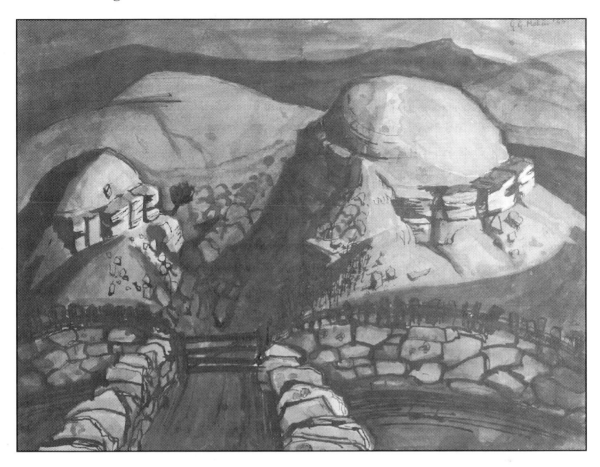

**In The Black Mountains of Wales
a painting by the Author**

Atlantis extended an arm near to the Cornish peninsula, as it then was, and towards southwest Ireland. The eastern shore went down the eastern North Atlantic, taking in what remain today as the Canary and Cape Verde island groups. Then a narrower arm penetrated deep into the eastern part of the South Atlantic. The broad northern part of Atlantis approached close to the present mouth of the Orinoco River. Further north it included some of the area occupied by the Caribbean Islands, continuing quite close to the North American coast. The northern shore, for the most part, was a little further north than the Azores.

Climatically, Atlantis ranged from temperate to tropical. The population was very large, and the people ranged from those with fair, or red tinted hair and pale skins, to black skinned people, all held in equal esteem.

Many cities were built, apart from the capital, Numenor. Alta was the second city, and a large seaport, near to present day Bimini, was called Poseidonia, in honour of the sea god. Near this city stood a temple, dedicated to Poseidon, and by this temple, was a marble fountain, called the Fountain of Healing, through which flowed the waters of a deep mineral spring.

Beneath the sea, it flows to this day, the water above it being extraordinarily buoyant. It has been found, but those who know do not speak of it, so that it may be preserved.

The Creator was worshipped, and the people were aware of the Sky Gods, for they visited them in human form, coming down in the circular vehicles to land on the high platforms. I will give the names and functions of those of whom Amy was permitted to tell.

Beeal and Beealtis, Rulers of the Sky. Beeal, with his wife Beealtis, have charge of the ordering of all the bodies and systems of space, of the universe. These two are at the top of the hierarchy of the Sky Gods. They also proclaim that the masculine and feminine principles are universal, as is the balance symbolised by the Yin Yang sign, which may be found in the Celtic Book of Kells, as well as in the Chinese culture.

> Pan has charge of mankind, the animals and the trees, on all planets where they live.
> Hera is the Earth Mother, spirit of the living earth and of all planets where there is life, as we know it.
> Ashtoreth is the Moon Lady, goddess of our moon and of all others.
> Eeyar, the Fish Man, is a teacher. Once he came to the Chaldeans.
> Ma is the Goddess of the Leys and of the invisible forces within the earth.
> Sul is the Lady of Sweet Waters.
> Nodens is the Sky Traveller, the messenger, through whom communication is maintained throughout the universe, regardless of time and distance.
> Kundalani, The Serpent, the current of life.
> Lugh, the Sun God.
> Cerebus, God of Weather and Flowers.
> Orpheus, the Sweet Singer of Words, god of the musical and poetic sensibility.
> Poseidonis is the God of the Seas, here and elsewhere.
> Jove, the Thunderer, the god of electro-magnetic forces.
> The God of Water, Healing and Magic.
> The Goddess of Love and Art, Aphrodite. I do not have Amy's word for linking that name with this goddess, though I have reason to believe it to be correct.
> Ishtar, the Lady of Venus.
> Até and Sathanoz, the Evil Ones, whose function as tempters is essential for the development of our spirits through many lifetimes.

These certainly form a most puzzling list. I tried on many occasions to persuade Amy to make the meanings more clear, but she had a way of deflecting my questions. As with many other things, my inner promptings led me to understand some meanings, which Amy would then confirm and sometimes lead me further into them, but this did not happen often where the gods were concerned. All I can say is that, however strange this list may appear, knowing Amy and all her abilities, I must regard much of this as a puzzle I was set, but largely failed to solve.

From their original habitat, the people brought their arts, science, technology and religion, as nearly as I can express these things in our terms, for fundamentally it was a unified

knowledge, where all these aspects functioned together, interacting with the realm of spirit and the gods. Life was in harmony with, was part of, the cosmic system. If there was a fall of man, it was when this was forgotten. Yet this knowledge was carried down to our time by Amy, one of its nine Guardians. What I have been given is but its faintest shadow, yet even this may kindle a light somewhere. As it was with me, someone may think, many lives ago, I once knew these things.

I quoted from The Words concerning the coming of the asteroid, 'the Star', which destroyed Atlantis. Other cosmic events were also recorded. A great flood is remembered in the traditions and lore of many peoples around the globe. Some say that they all remember the effects of the destruction of Atlantis, others that the stories recall local cataclysms. Part of The Words that I am allowed to quote says,

> As a mother lovingly wraps her babe, so was Planet Earth wrapped in a
> veil of water to protect her from the fires of Heaven.

It is explained that the earth once rotated at a faster rate than now, and that it occupied an orbit nearer the sun. Held aloft by its spin was a watery sphere. Earth was like a ball within a bubble. A large body approached, and its gravitational pull drew Earth farther away from the sun. It also slowed Earth's rotation. The enveloping watery mantle fell, resulting in a great deluge all over the earth, causing worldwide destruction and death. The incoming body and Earth were snared by each other's gravity in the binary dance of Earth and Moon.

When moon rock was brought back to Earth, it was found to be older than our planet, thus destroying the long held notion that the moon was once torn from the earth. The Words say that the moon saw inhabitation before the earth.

There was a later event. The Chinese apparently have no flood legend, as have most peoples. Amy called them the Venus people, saying that Venus was once further away from the sun. A Velikovsky-like disturbance of the solar system drew Venus nearer to the sun, and people were brought from Venus to Planet Earth. The Chinese are their descendants.

In discussing these cosmic things, I am reminded of a conversation I once had with Amy, when I said that I had heard that an American space probe had passed near to Jupiter. It had detected an unexplained region of great heat at some remove from the giant planet. Amy's expression was very serious as she said, "So they've found the Black Heat." She told me that when air travel was in its infancy, her grandmother predicted that one day this region would be found, and she had been upset at the thought of men blundering into it, for they and their craft would be destroyed. Amy remembered tears in her grandmother's eyes at the thought of it. I asked Amy if absolutely anything would burn up in that place. She told me that this was so, and that it was where things were sent for destruction. I presumed that she meant physical objects. "Anything," Amy said with great intensity.

Yet another thing comes to mind. A television current affairs programme described how British engineers had drilled down into a subterranean region of heated rock strata in Cornwall. It was planned to pump water down and return it heated to the surface, to use for power generation. The attempt proved a failure, because the water simply dispersed into a layer of porous rock and disappeared. I recalled then that quite a long time before, Amy had told me that electric power had been generated by Atlanteans in Cornwall by this means.

Another method of power generation used in Atlantean times, Amy told me, was by means of tide-operated wheels. I found a photograph in a book of a sculpture found near Elche

in southern Spain. It is said to be prehistoric, but clearly quite unlike anything else known from such early times. It is a limestone bust of a woman, more naturalistic in treatment than was common in Egyptian work, less idealised than classical Greek sculpture, and clearly a portrait. The heavy features are those of a middle-aged woman, simplified with consummate skill to retain her character. Her shoulders are hunched and indicate a fullness of figure. Her clothing is obviously woven fabric, with delicately carved folds, arranged naturally, unlike the formal patterning in classical work. She also wears an intricate double necklace with unusual pendant ornamentation. However the most striking features of the work are the two wheel-like shapes on either side of her head. These have a diameter, which reaches, from the level below the mouth to almost the crown of the head and resemble paddle wheels of very complex construction. From between the wheels and the head cable-like objects hang down, seven on each side. Amy told me that this is a bust of a priestess from the temple of the sea god, on the eastern shore of Atlantis, facing the Iberian Peninsula. The structures on the sides of her head represent the tidal wheels used for generating electricity.

I was so intrigued by this explanation that I made a ceramic sculpture of the female head, with wheels on both sides and the hair becoming a flow of water turning them. It was in no way a copy of the Lady of Elche.

We will return for a moment to the visual encoding of knowledge.

On a much smaller scale, there is one more encoding of the ancient knowledge that Amy showed me. I have said that she was skilled at lace making and crochet work. Many of the patterns she used were traditional, having been handed down in her family. Specially shaped to fit the curved back of her favourite chair was an elaborately worked piece of crochet work. It was circular, but the centre was raised to fit over a wooden knob in the centre of the top of the chair back.

Amy had been the organist for a little country church at one time, and, with a sly grin, she told me that she had made some lace pieces, or webs as she called them, for the altar candles to rest upon. The designs were symbolic of things concerned with her beliefs. It will be apparent from the Book of Kells symbolism already discussed that Amy's beliefs were not anti-Christian, rather that they extended Christianity by placing it in a wider context, though of course it did not agree with much of the various churches' interpretations of that faith. In Amy's mind, she was committing no sacrilege. For the church was doing plenty of that, however unwittingly at that time.

Following this confession, I asked Amy if she had any examples of her work embodying ancient symbols. She pointed over her shoulder to the crocheted piece on the back of her chair. It was, she said, a traditional Cornish pattern, and showed me a photograph of the same design in a magazine. She called it The Turning Star. And so it was, for the many-pointed border of the central large shape connected its centre by curved lines, suggesting rotation. From the recessed angles between the points of the star, there were projected forms extending into the surrounding space, tapering towards the outer ends. Projecting from the sides of these shapes was swept back shapes, like the wings of a jet plane. Like plumes, other shapes extended from the narrow ends of the radiating forms.

I remarked that these combined shapes looked exactly like jet planes. "Rocket propelled planes," Amy corrected me. I commented that I thought that the Atlanteans used circular 'vehicles'. "Rocket propelled space ships were also used," she said.

It had never occurred to me that these largely female crafts had such a tremendously long history, but then I thought of the finely made dilly bags, made by aboriginal women in Australia from knotted string of native fibres. Aboriginal occupation is constantly being pushed back, now, I believe to 60,000 years. Will it stop there, I wonder? So how old are their crafts?

'The Lady of Elche'

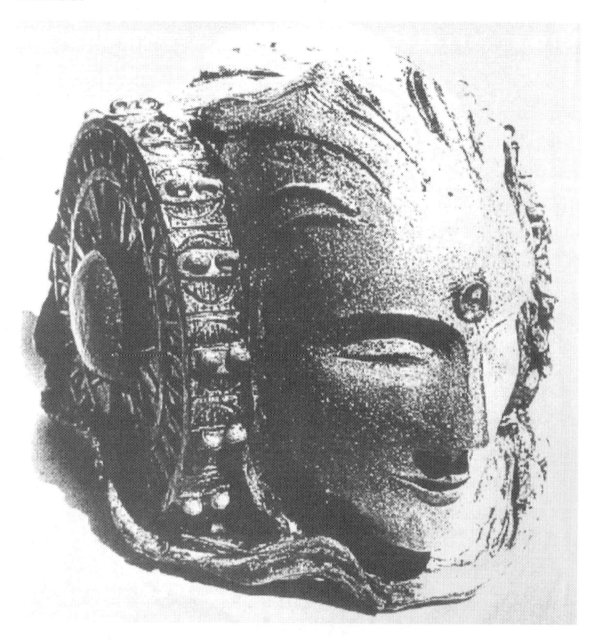

Ceramic sculpture by the Author

CHAPTER 8

Glastonbury Tor

Many people are aware of that remarkable hill, crowned by a tower in the English county of Somerset, known as Glastonbury Tor. The town of Glastonbury, with its abbey ruins and the Tor, have achieved fame, if not notoriety, for their attraction to hippies, New Agers and rock fans for many years, but Arthurian legend and old traditions have long centred upon Glastonbury. People who have read about leys understand that the ley which begins at Itkis, or St. Michael's Mount, passes through the Tor. When my wife and I visited Glastonbury, and climbed to the summit of the Tor, it felt curiously dead. It did not have that feeling, which I can only describe as peaceful-yet-lively, that I find on elevated points on leys, as for example on lovely Dinedor Hill, near Hereford. From a Scots pine on the edge of its ancient earthworks, the tower of Hereford cathedral and the spire of All Saints church align, as shown in Alfred Watkins' book, The Old Straight Track. That ley is alive and healthy, but the one which crosses the Tor gave only a faint pull on my dowsing rod. Likewise my wife found it weak, though she could track its direction.

The Tor has had a chequered history. Because it had been a revered site in pre-Christian days, the new religion tried to claim it for its own by building a church upon its summit. Originally the Tor had been crowned with a tall standing stone. Is it not strange that an earthquake destroyed the church, but left its tower where the stone had stood? Perhaps it is no stranger than that the cathedral built on the ancient site of Old Sarum had to be abandoned because unexplained events made it untenable, and a replacement was built at Salisbury. Incidentally both these sites are on a ley, which aligns them with Stonehenge.

The last abbot of Glastonbury, at the time of the reformation, was hanged upon the Tor. Such a terrible event upon a ley would diminish its power, as would the careless feet of too many sightseers. The ley could be mended, but who is there in England with the knowledge to do it? As with the Tor, I would have expected more 'life' in the abbey ruins than I found, considering all the lore that attaches to it. It was a different case with some of the small fragments of the original abbey that had occupied the site previously. These are exhibited in the small museum beside the abbey ruins. They gave a strong dowsing pull. I wish I could offer a satisfactory explanation for this.

In connection with the ley which crosses Glastonbury Tor, I have read of dowsers who have claimed to have followed its path right across England from Itkis to the Suffolk coast. They write about what they term male and female tracks, winding and drifting about, following the general direction of the ley itself. These are not the ley. Leys are quite straight, unless they change direction at clearly defined points. Of course they must follow the curvature of the earth's surface, and so may not appear quite straight on the projection of the map. Certainly these dowsers followed genuine lines, for there are other forms of geodetic line than leys, and some of these follow the general course of leys. Dowsers can be attuned to certain things but be unable to detect others. The lines in my garden have been detected and followed by several people other than myself, yet a very able diviner, who could detect water and minerals, was unable to find them. Guy Underwood wrote a fascinating little book, The Pattern of the Past, in which he describes three types of line, other than leys, and how they relate to ancient

structures, like Stonehenge and also to mediaeval churches and cathedrals. He seems to have been quite unaware of leys. All these things are genuine phenomena and I wish that someone could explain how they all relate and operate together. Certainly Amy could have done so, had she been permitted, though she did say that lines that transmit the power are associated with leys, but are distant from them.

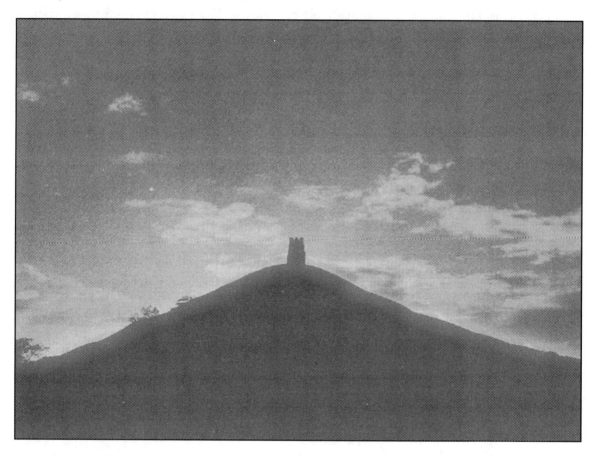

Glastonbury Tor

Returning to my main theme, Glastonbury Tor is the most visually outstanding of the many hills in the area, because of its height, shape and the tower on its summit. In the 1920s, Catherine Maltwood, a sculptor, began to notice shapes in the landscape. Hills, watercourses and ancient track ways, now frequently modern roads, defined forms, which she recognised as signs of the zodiac, in a circle twelve miles in circumference. Abandoning sculpture, she gave her time to research and completed a map of zodiacal figures, and published her book, Glastonbury's Temple of the Stars (1935, published by John Watkins). In 1978 Mary Caine published her book, The Glastonbury Zodiac, Key to the Mysteries of Britain. In this the author fully acknowledges the work of Catherine Maltwood, but believes that she has continued and refined her work. I think that this is true, and will explain why.

My wife and I were shopping in Tasmania's second city, or northern capital, Launceston, with its many fine buildings. While my wife went into a department store, I decided to continue along Brisbane Street, to Petrach's bookshop. As I entered, I felt a strong vibration coming from my left. It was quite unexpected, and I stopped dead, wondering what could be

the cause of it. To my left was a freestanding set of bookshelves. Seeming to stand out from the rows of books was a narrow white spine with the title in black print. I approached. I read, The Glastonbury Zodiac, Mary Caine. If it were so important that I had been guided to it in that extraordinary manner, I had to buy it.

I showed my purchase to Amy, and of course she knew all about the Zodiac. It had, she said, been made by Atlanteans, and there were other zodiacs in various parts of the earth, yet to be discovered; where she would not say.

After studying the black and white diagram of the twelve-mile wide circle of zodiacal figures in Mary Caine's book, I could not understand why my attention had been so particularly attracted, other than that I was to be reminded of the zodiac's existence. Was there something more to be found, another figure missed by the two researchers perhaps? When I asked Amy that question she said that, yes, there was.

I sat at home staring at the diagram, turning it around and back again, but could see nothing further. Then I thought of my art training, where I was taught to realise the importance in design of the shapes left between those which are actually drawn. These are termed negative shapes. Again I rotated the diagram. Suddenly it was there. Far larger than any of the black shapes was a gigantic white horseman, helmeted and holding what might be a flail, his horse rearing in a forward leap, with back legs apart and front legs extended.

Amy had not thought that I would find the great rider. She told me that I should tell no one of it. Now, at this much later time, through the medium of the pendulum Amy herself made for me, my guides tell me that there is no longer such a prohibition.

Glastonbury Zodiac—Grail Legend

The horseman, said Amy, is Arthur. Arthur: the king who has spawned a thousand legends. But how could this be? Amy told me that King Arthur was one of the incarnations of Pan, at the time when the Angles and the Saxons were overrunning England. How then could this be Arthur in a depiction of such great antiquity? Legend has called Arthur the Once and Future King. So time and Arthur are linked together. In the zodiac is a representation of the cycle of the Great Year, which completes the precessions of the equinoxes, the cycle represented on Ross Bridge and in the Book of Kells. It tells us that Arthur is there always, through every cycle, to ensure the continuity of the knowledge, that the endless thread may never be broken. Before Atlantis was, and after our age has ceased, it will continue. And, of course, Arthur is an aspect of Pan.

The Grail legends have their roots in times much earlier than Christianity. In Celtic mythology there are magic cauldrons, round vessels. The night sky is likened to an inverted bowl, 'The bowl of night', as in the Rubaiyat of Omar Khayyam. The figures of the Glastonbury Zodiac bear an exact correspondence to the stars in the night bowl above. The Holy Grail is something sought, but exceedingly difficult to find, and it is always linked to Arthurian legend. Arthur and the Grail cannot be separated, for he is within the Grail and they have both been found.

Amy once hinted to me that there was some link between ancient Sumer and Somerset. Only recently have I found it. In the world's oldest known epic, Gilgamesh, recorded on clay tablets, are hints of a zodiac in the far west.

In local folk memory again there are hints of the Zodiac, as there are in place names within the great circle, and it was known to the early Welsh bard, Taliesin. In his poetry he castigates the monks and bards of his time for their lack of knowledge of it. But like the artist of the visual symbols, he veils his meaning, but much of what he wrote only makes sense in the light of this knowledge.

CHAPTER 9

Experience of spirits. Summary of beliefs

We have seen that in this ancient tradition we are believed to be spirits, who for a time inhabit and express ourselves through the medium of a body in this world of matter, before returning to our real home, prior to another earthly journey. The schoolboy with the heart condition saw aimless spirits, and was told that they were people who committed suicide. Because they had rejected the Creator's gift of learning and growing, through every experience of life on Earth, they were not for a time allowed to go on, and could not escape from the trauma that had driven them to destroy their bodies.

It is not only suicides that remain bound to Earth. Some who die in very difficult circumstances may be too confused to find their way, Amy told me. These may for a time remain here, sometimes being perceived as ghosts. Others, who may have done great wrong in their lives, may not go on, fearing judgement. These are able to do much mischief, for they can learn to affect our minds. Fits of depression, of long or short duration, may be their work. In extreme cases these spirits may cause mental illness. I have had no personal contact with this, and I rather balk at the idea of going to a mental hospital and telling a doctor that some of his patients may be affected by bad spirits! Some people, weakly anchored in any moral code, may succumb to the suggestion of spirits to commit crimes. Who knows how many?

For me the groundwork for awareness had to be laid by my talks with Amy and from reading about near death experiences. I also needed to have gained confidence in using the pendulum Amy had given me before a certain suspicion could form.

I was painfully concerned that many of my thoughts and attitudes were contrary to the qualities I saw in people I admired, and that these traits had been part of my mental makeup for as long as I could remember. This awareness was rather dim and muddled, a kind of discomfort with myself, a feeling of something wrong which I could not deal with. I am quite sure that Amy clearly saw all this, but knew that I would eventually be able to solve my problem.

The day came when I asked if any malevolent spirits had attached themselves to me. Through the pendulum I was told that there were two, and that they had been with me from the age of two and a half. I know, for I was frequently told, that I had been a difficult child, and I can remember many things I did that I regret, fortunately none of them too serious, though I could not account for why I did them. I could rid myself of these spirits. From that moment I felt a different person. Perhaps the greatest change was in my attitude to others, my concern for them and consideration for their feelings, and attempts to understand their attitudes.

These spirits never returned though I was for years plagued by others. I would feel depressed or unaccountably irritable. Amy could see spirits accompany me to her garden gate, though they could not pass through. She would stare them down and they would go away. As I realised the cause of my problems I began to send these unwanted guests from me in the manner described, but eventually others would come, to be sent away in their turn. This does not of course mean that I am immune from the common changes of mood that we all experience, but they are of a very different order from those of former years.

Having stated these things, it is difficult to advise others what to do about them. How can one be sure that a fit of depression is caused by a spirit, by the weather or a row with the boss? For most people there is no easy solution, and the matter is best left alone. However there is a small minority of people, with genuinely heightened awareness, who can detect the presence of spirits. I am not referring to dabblers in the occult. The people I am referring to do not use ouija boards or hold séances. They are well-balanced, intelligent and competent individuals, who simply have this added awareness. Because they are such people, they do not go about telling others of this faculty, for they realise that they would lose credibility.

If you are not such a person, it is useless, indeed dangerous, to pretend or to delude oneself. No one should ever attempt to contact these harmful spirits, with one exception. Should you genuinely be one of these gifted people I have described, and are aware that spirits from time to time trouble you, just say in your mind, 'Spirit with me, go through the tunnel to The Light. In the name of the Lord Pan, now go.' Should you perceive that some other person is being bothered by these spirits, say in your mind, 'Good spirits, please protect me. Spirit(s) with . . . come here to me now. Go through the tunnel to The Light. In the name of the Lord Pan, now go.' It does not matter how far away the person concerned may be, the spirit or spirits will be with you on the instant, for distance and time are different in the spirit world. If, however, the troubled person is within nine feet of you, there is no need to command the spirit to come to you. I am not able to give any reason for this.

I will describe here a disturbing encounter my wife and I had on an otherwise happy walk along a bushland path to a waterfall, when the kids were still kids and our dog was young and keen to go anywhere. The path crossed and recrossed the winding course of the infant river, by a succession of log bridges. At the final bridge my wife's legs began to shake, but the desire to see the waterfall helped her to overcome her reluctance to cross. In the pool below the cascading water, the children splashed about and scrambled over rocks, the dog never far behind, whilst we parents enjoyed the sight and sound of the water. My wife has a fascination with waterfalls and we have found that they are always crossed by a ley.

About two years afterwards we all went there again. Comedy intervened along the bush track. Our large, lovable, cowardly dog was leading the way. So cowardly was she that, if there were a knock on our front door, she would give her deep, authoritative bark, whilst backing down the hallway to the rear exit. Rounding a bend in the path she came nose to nose with another dog. In any other situation she would have run to us for protection. But this confrontation was so sudden, and the perceived threat so imminent, that she attacked in a defensive reflex. The other dog's owners attacked us verbally for allowing such a dangerous and vicious animal to be abroad in a public place. In vain were our attempts to explain the true nature of our now quivering dog.

We continued, a little shaken, a little amused, through the bush, sometimes open with waving grasses and foxgloves, sometimes enclosed with man ferns and trees. When we came to the last log bridge my wife could not cross. Again her legs felt shaky, so she remained behind with the dog, who did not care for log bridges anyway. So the children and I went on to the falls.

Many years later when the children were grown up, and sadly the dog was no more, my wife and I again walked along the path to the waterfall. The logs had been replaced by proper wooden bridges, making the crossings less hazardous. Yet when we came to the final one my

wife again felt an unaccountable fear. Her legs trembled and she felt very tired. I had to help her over. When we reached the falls she felt 'shaky and very peculiar'.

By this time I had learnt to take notice of any atypical reaction on my wife's part, suspecting that her intuitive mind had tuned into something. As we sat on a log watching the plunging water, I pondered the cause of her fear. I was without my pendulum and so could not ask questions, but I made a guess that there were malevolent spirits in the area immediately around the bridge.

Perhaps, I thought, I could make use of my wife's sensitivity. As we headed back along the path, I asked my guardian spirit to give me a sign through her, if I should address the spirit or spirits at the bridge. Turning around to my wife, who was a few paces behind me, I asked her to take my left hand, asking her if she could feel any reaction. She said that she felt more relaxed and that her sense of foreboding at the thought of approaching the bridge had gone. I took this for the requested sign.

The path turned a corner and there was the bridge, a few paces ahead. I stopped and asked my guardian for protection. In my mind, I addressed the spirits, telling them, in the Lord Pan's name, to go through the tunnel to The Light, but first I had to call them to me. As I did so my wife clutched my sleeve. Later she told me that she had felt herself falling backwards. A moment later the bridge no longer held any terror for her. Its environs were as peaceful as the surrounding bush.

At home, with my pendulum, I asked questions. It seemed that there were nine spirits by the bridge. They had been convicts transported from England, and later released on ticket of leave. At the place were the bridge now stands, they had murdered eleven Aborigines, men, women and children, not shooting them, but killing them slowly and with torment. Upon their own deaths the convicts' spirits were compelled to go to, and remain, at the place of their crime. Though nothing can alter the appalling wrong they had committed, the guilt, misery and animosity have left the location. It is clean, but I was too sickened to ask further questions.

My wife had done nothing to encourage or to have anything to do with those spirits, yet they could have endangered her on the log bridge. Malevolent spirits are dangerous. Once again I have to stress that, if you can sense their presence, do nothing but send them on, in the way I have indicated.

Another example of interference by malign spirits was when, on holiday, we were driving through the Australian state of Victoria. Wanting a midday meal, we stopped in a country town, where we found a Chinese restaurant.

Once we sat down at a table, it was evident that my wife felt uncomfortable. She intimated that she didn't like the place, though she was not insistent that we leave, since that might have been something of an embarrassment. To me, it was a perfectly normal Chinese restaurant, clean, with the usual decorated light fittings, wallpaper and numbered menu. We ordered, we ate and we left. I was perfectly satisfied.

I had driven a long way from the Tasmanian ferry terminal in Melbourne and we still had a long road ahead of us. Consequently my wife took over the driving. She is a very competent driver, having had her own car for many years, and never having been involved in an accident. Shortly after we set off she began to swing the car to left and right in a most dangerous way, until we came to a T-junction, where we had to turn right. We certainly turned right, straight across a stream of traffic, cutting into the opposite lane. Somehow we survived. Fortunately

my wife heeded my desperate plea to pull in to the side and stop. Recovering a little I tried to account for this so uncharacteristic behaviour. It seemed as though someone else had been driving, someone completely reckless and unheedful of the consequences.

Happily, that thought made me think of spirit possession or influence, so in my mind I told whatever spirit was with my wife to leave, and I called on Pan's help. Immediately my wife seemed to come out of a daze, and was again her normal self, though horrified at her performance. She said that she was just swinging the steering wheel around, back and forth, not caring about anything.

Evidently she had been aware of something in the restaurant, and it had joined her in the car. Since I am not usually sensitive in that way, I had been completely unaware of a presence, just as I felt nothing on our walks to the waterfall. I can only speculate about possible numbers of vehicle accidents caused in this way. We were lucky to survive. Or were we protected? Certainly it was a learning experience.

I have recorded how malevolent spirits may remain in a certain place, but they may also inhabit objects. On a visit to Bath, in the English county of Somerset, we visited the ruins of the Roman baths. On exhibition were some stone coffins. Both my wife and I experienced a very bad feeling emanating from them, though whether in this instance it was malevolence or misery, I am unsure. This feeling evaporated as soon as I 'spoke' to the spirits associated with these coffins, in the manner I have previously indicated.

On another occasion, in Vienna, we were in the Kunsthistorisches Museum, when we saw an Aztec stone sculpture, in a glass case. Even by Aztec standards it was ugly, and a strong feeling of evil seemed to possess it. Again I was able to dispel this. But it was nothing compared with what we both experienced in the Greek sculpture room.

It was closing time. The museum staff was pulling blinds down over the windows, and we were obviously meant to depart. Suddenly our attention was drawn to what appeared to be a late classical female figure on the further side of the room, away from the path we were following towards the exit. Whatever its colour in full light, in the deepening shade it loomed dark and ominous above the smaller works around it. The feeling of menace from this thing was of another order altogether from anything I have experienced before or since. It seems so strange that this was a product of classical Greece. What could be inhabiting it? Was it put there by man alive, for this is a possibility? Presumably it is still there, for lack of time I was unable to do anything about it. I know that I have protection, but a part of me is thankful that I did not have an opportunity to face that awful presence.

When I thought I had completed this book, a very troubled young woman I knew asked for my help. This is her story and my involvement in it, together with two other short tales.

Some years ago a girl found a fragment of paper in a second hand wardrobe her parents had bought for her room. On this paper the name, Alice, was written in a decorative script. She felt that there was something special about this name, that it had some indefinable significance, so she kept the paper safely.

Who could Alice have been? The paper was yellowed at the torn edges and obviously old. Did Alice still live? What was her full name? Alice became almost an obsession with the girl, who was yet to realise her true psychic nature. Eventually, and perhaps inadvisably, she showed the paper to a friend, who suggested that they held a séance. With a mixture of excitement and trepidation, they wrote the letters of the alphabet in a circle and put an inverted glass tumbler in the centre. Placing their fingers on the tumbler they asked aloud the question,

"What was Alice's surname?" Seemingly moving on its own, the tumbler glided from letter to letter, spelling what seemed to be a rather unusual name, which they recorded.

It was many years later that I met this young professional woman in the course of my work. In conversation with her, it became clear that we shared certain interests and that she was psychic. I give an example of her gifts.

She had lived most of her life in the Tasmanian town where she now worked, and she told me, that certain locations within it held a particular significance for her, because of certain things which had occurred at them. She did not volunteer any information about their nature.

In the building where we were both working she showed me a street plan of the town centre, together with a photocopy of it. She wished me to use my pendulum to find, and mark in, the leys running through the town on one of the plans. I agreed to attempt this, though I felt it unlikely that leys would still be present in such an urban environment.

We found an empty room and she took one plan to the far side and marked in the locations she felt about so strongly. I remained near the door and began to dowse over my plan. To my surprise the leys were easy to find and I ruled them in.

When we had both finished we laid the plans side by side. All the locations fell upon the leys I had marked, and several were on ley crossing points. This was proof enough to me that she indeed had a degree of genuine psychic ability, though previously I had had some doubts; but to return to Alice.

Thoughts of Alice so obsessed this young woman that she wrote a fictional book with Alice as the main character and published it privately with the help of a friend. The book was launched, with local press and television coverage, from a large old house, in perhaps the most prestigious residential district of the town.

But nothing seemed to go right. People came, but seemed more interested in looking over the house than in purchasing the book. The friend who had helped quarrelled with her, as did other people. Alice, always Alice, was continually in her mind and it almost—rather more than almost—seemed that Alice was fighting the whole project.

I was walking along a corridor in our workplace, when the aspiring author drew me aside from the other people around. In a near whisper she asked me if we could go somewhere to talk. Seated in a quiet corner she asked me if I could find out if an Alice spirit was haunting the big house and causing mischief for her. Then she told me that she had done some research into the people who had lived in that house in the past. One was an Alice, with a surname almost identical with the one given in the séance years before.

I was not carrying a pendulum, and we had to search around for materials to make one. Earlier in my dowsing I only used the pendulum Amy had given me, but fear of losing it drove me to ask if I could make and use others. It seemed that I could, so I put Amy's pendulum in a safe place and made pendulums from a variety of materials. On this occasion we found a length of nylon thread and a small metal mechanical part as a weight.

Once more we found an empty room, and I began to ask questions. Yes there had been an Alice and she had died, but her spirit had not gone on. She was very unhappy that a book had been written, supposedly about her, bearing no relation to her real self. Yes I could call her to me. I should 'talk' to her, explaining that the book was simply intended as a fictional work and that it meant no disrespect to her.

I called Alice, and the pendulum indicated that she was present. My friend felt a slight headache and, to my surprise, there was a very slight vibration in my head. I thanked her for coming and made my usual expression of sympathy and understanding of her condition as a discarnate person, before telling her of our nature as reincarnating beings. Going on to explain about what she might perceive as a tunnel and the expectation of the Light, I told her that she had nothing to fear by entering and that she should take courage and leave her familiar surroundings. For some moments she refused to go, until I said, "Go in the Lord Pan's name". Then she left us for the other world. The headache and the vibration also departed.

I don't usually think about ghosts, and have had no personal experience of haunting. Likewise I don't think about the living and the dead, but simply about people, who may or may not at this time be incarnate. On one occasion, however, I appear, if I have to use the expression, to have 'laid a ghost'.

A cleaner in a college I was associated with complained to me that, when he was alone at night in the building, doors would slam. I asked in the usual way if a spirit was responsible for this, and was 'told' that this was so. I called it to me and sent it on. That was the end of the nocturnal slamming doors.

But this reminds me of the tale I was told on a visit to England. An acquaintance had been the caretaker of a school in north-east Essex. He was asked to take a large carton to a certain room. It was night when he carried the carton along a corridor, but he could not turn the doorknob without putting the carton down, which he was reluctant to do, since it would be difficult to lift it again. Aloud he said, "I need another hand." A hand appeared over his shoulder, opening the door. "Thanks," he said and turned. The corridor was empty and he knew for certain that he was alone in the school!

POSTSCRIPT

I had nearly finished writing this book when I found a book in a local branch of the State Library, called The Mystery of the Crystal Skulls. At first the title may seem misleading. It is not a cheap thriller, but one of the most fascinating books I have ever read. The authors are Chris Morton and Ceri Louise Thomas, and the publisher is Thorsons. The two writers followed a trail, which finally led them to win the confidence of Native Americans who are steeped in the traditions and lore of their people. Most of these were articulate and well educated. Some were professional people. Although they represented different tribes or nations, their beliefs were essentially the same, from every part of the Americas.

The authors were invited to be guests at a meeting of four hundred representatives of peoples from the far north to the furthest south of the American continents, which took place at Tikal, in Guatemala in 1997. There it was decided that it was the right time for their beliefs to be made known to the world at large. They call our time The Time of Warning. They tell of people coming from the stars, and they recall how teachers came from Atlantis. They call for love of the earth and of all living creatures, and for love and peace between people. They talk of the cycles of time and of reincarnation.

Essentially their tale is Amy's tale, from the opposite shore of the Atlantic Ocean. Remember the passage from The Words beginning, 'And came the star,' and the passage I quoted from the Popal Vul? It was good to have this testimony in support of what I had been taught by Amy, from a people who had not been in contact with the Celtic world in historical times. I hope I may learn more.

Much of what I have written concerns intuition, and I have tried to enlarge our appreciation of that faculty, not to bring it into conflict with reason and scientific thought, but to complement them, enlarging our appreciation of the totality of our vision, our environment and our being. For what is intuition? It is a means by which our guiding spirits speak to us. Intuition is not unreason, but guided apprehension. We can of course mistake wishful thinking, or superstitious interpretation of what we take for signs, as intuition, just as faulty reasoning is mistaken, but unreason can be much more dangerous. We are seeing many manifestations of unreason in the contemporary world. The old, though frequently mistaken, securities, which bound people's lives in bygone times, have melted away. This has prompted some people and groups to manufacture spurious security in new religious cults and fundamentalist sects, as distortions of more than one religion. Shout something loudly enough in a crowd, follow a charismatic leader, and you have possession of the one and only truth. Fight for it. Die for it.—Forget it!

Our capacity for reason is a gift of the Creator, but some areas of life and experience are not amenable to reason alone. Love and any form of art are of this order. This is why they are linked in the Goddess of Love and Art. People have frequently attempted to make what they believed to be logical rules for the arts, but although they may have had some limited application, they have always been overthrown by new ideas and areas of exploration. Love, beauty and art, although there are aspects of them which may be discussed and reasoned about, for them no lasting rules of universal application can be made.

Now, what finally are my beliefs about the things I have experienced and been taught? I have no desire to preach. There has been too much preaching for too many centuries. But

having written what I have, I will say what I believe, recognising that others must find their own truth. Mine is this.

All life is sacred; therefore we should do as little harm as possible to all living creatures, consistent with our own ability to live. Likewise we should do no harm to the earth, for she too is a living being and our life support. We should work for the peace of the world, helping others as we may in kindness, not as a duty. We should employ the time we are given to learn, but never to apply our knowledge in ways that are inimical to the lives and freedoms of others. We should remember that throughout all our lives we have a guardian spirit, who speaks to us through our conscience and through intuition. We should always be grateful to the Creator for the life given us as we progress through our incarnations, for the opportunities to learn and to exercise our creative potential, for beauty and for love. When sorrow and suffering come to us, we know that they must end. Always we will have new life, but that life will be affected by how we live now, and by what we learn. In the life between earth lives, we make our choices for the next incarnation, and we may choose the soft option or the hard. Through the latter we have more opportunity to progress. Whatever our situation we must embrace life.

And what have I learnt of past and present? As I was taught, it became apparent to me that all of the years of our history have been a sleep, in which we have forgotten our origins, our purpose and our destiny. We are the disinherited, robbed of our birthright. Despair or dull resignation haunts our western centuries like twin ghouls, gibbering and beckoning on the edge of vision. In the place of the love that gives us as many opportunities as we need, we have been given one chance, followed by the Last Judgement, in the name of perfect love.

When the ocean engulfed Atlantis, we drank of the waters of Lethe that we might not again abuse the great knowledge once held, and for long we dwelt in ignorance and superstition. New promise we knew in Greece, in the Renaissance and in the Enlightenment. Freedoms then won so gloriously eventually forged the chains of today. Dogma dethroned, intellect freed, and the exploration of the visible and tangible universe made man the master and the measure of all. In mastering all, in imposing his will on nature, much has been gained materially for the developed nations, at the expense of the majority of mankind, at the price of depleting the Earth's resources, fouling our environment, and wreaking changes that may prove impossible to reverse.

I am no prophet of doom, yet I cannot help thinking of those cycles of time represented so graphically on Ross Bridge. If we destroy much, or even all, that we have made, done and been part of on this planet, the spirits of some have reached that stage at which they have no need to return here, in this cycle or any other. Time and the Good Earth have not been wasted.

THE ENDLESS THREAD

Sources of illustrations with Page numbers

p. 3 Causeway Through Pond, Ten Houses, Holmer Book, The Old Straight Track.
Fig 59 opp. P81
Author. Alfred Watkins
Publisher. Abacus, Sphere Books Ltd, 1974 through 1980
Copyright. Alan Watkins, Miss Marion Watkins
Page 44 Mound with Trees. Cover Photo for above book.
p. 5 Nine Gaudians Ceramic. Authors Work
p. 26 Panorama Stone
Book. Circles and Standing Stones. Opp P157
Author. Evan Hadingham
Publisher. Abacus, Sphere Books, 1987
30-32 Gray's Inn Road, London WXIX 8JL
P. 29 & 37 Book of Kells. Ancient Irish Manuscript
p. 30 Spiral Galaxy. Unable to trace source of photograph.
p. 38 "Triples on a Cross' symbol. From a book by Arthur Guirdham
p. 41 Ley at Latrobe. Author's photograph.
p. 46 Falling Star. Drawing by Paul Nash, 1911.
Book. Paul Nash, A Memorial Volume, Plate 5.
Publisher. Land Humphries, London and Bradford, 1948.
P. 45 The Wood on the Hill. Plate 7
As p. 46
P. 53, 54, 56, 59, 60, 62, 63, 65, 67, 69, 70, 71
Book. Ross Bridge and the Sculpture of Daniel Herbert
Publisher. Fuller Bookshop (Publishing Division)
140 Collins Street, Hobart, Tasmania, Australia 7000
www.Fullerbookshop.Comm.au
P. 58 Cronos. Author's drawing
p. 73 Gateway to the Sun
Book. The World's Last Mysteries, P. 138 diagram
ISBN 0285622110 1977
Publisher. Reader's Digest Services Pty Ltd
p. 78 In the Black Mountains of Wales. Author's own work and photograph.
p. 85 Glastonbury Tor
Book. Earth Rites, p. 7
Authors. Janet and Colin Bord
Publisher. Granada Publishing Limited. 1983
ISBN 0586 08452 5
Copyright © Janet and Colin Bord 1982
Granada Publishing Limited,
Frogmore, St. Albanis, Herts AL2 2NF, UK.

And 36 Golden Square, London,
WIR 4AH, UK.
p. 87 The Glastonbury Zodiac with Authors highlight of the central figure.
Book. The Glastonbury Zodiac: Key to the Mysteries of Britain
Author. Mary Caine
p. 82 The Lady of Elche
Book. The Mystery of Atlantis. Opp. P. 87
Author. Charles Berlitz
Publisher. Souvenir Press Ltd.
43 Great Russell Street London WCIB 3PA
ISBN 0285622110
p. 83 Sculpture. Author's work and photograph.

BIBLIOGRAPHY

Thom, A. Megalithic Sites in Britain, 1967, Oxford University Press.

Devereux, Paul. Earth Lights, 1982, Turnstone Press.

Graves, Tom. Dousing, 1976, Turnstone Press.

Watkins, Alfred. The Old Straight Track, 1925, Methuen. Paperback edition, 1974, Abacus Books.

Bord, Janet and Colin. The Secret Country, 1976, Elek Books. Paperback Edition, Granada, 1978, 1982.

Bord, Janet and Colin. A Guide to Ancient Sites in Britain, 1978 Granada.

Robins, Don. Circles of Silence, 1985, Souvenir Press.

Underwood, Guy. The Pattern of the Past, 1973, Abelard-Schuman.

Critchlow, Keith. Time Stands Still, 1979, Gordon Fraser.

Devereux, Paul. Places of Power, 1990, Blandford.

Screeton, Paul. Quiksilver Heritage, 1977, Sphere Books.

Crowley, Brian and Pollock, Anthony. Return to Mars, 1989, Matchbooks.

Hadingham, Evan. Circles and Standing Stones, 1978, Abacus.

Berlitz, Charles. The Mystery of Atlantis, 1976, Souvenir Press.

Crowley, Brian and Hurtak, James J. The Face on Mars, 1986, Sun Books.

Velikovsky, Immanuel. Earth in Upheaval, 1978, Abacus.

Moody, Raymond A. Life After Life, 1976, Bantam.

Michell, John. The View Over Atlantis, 1973, Abacus.

Watkins, Alfred. The Old Straight Track, 1974, Abacus.

Ash, David and Hewitt, Peter. Science of the Gods, 1991 Gateway Books.

Thomas, Andrew. We Are Not The First, 1996, Sphere Books.

Baigent, Michael. Ancient Traces, 1999, Penguin.

Cremo, Michael A. and Thompson, Richard L. Forbidden Archeology, 1998, Bhaktivedanta Trust International, Inc.

Saborn, Michael B. MD. Recollections of Death, 1982, Corgi Books.

Leininger, Bruce and Andrea, with Ken Gross, Soul Survivor, 2009, Hay House.

Cathie, Bruce L. Harmonic 33, 1968, A.H. &A.W. Reed Ltd.

Benedict, Gerald. The Mayan Prophesies 2012, 2010, Watkins Publishing

Morton, Chris and Thomas, Ceri Louise. The Mystery of the Crystal Skulls, 2002, Bear & Co.

Guirdham, Arthur. The Cathars and Reincarnation, 1982, Turnstone Press.

Guirdham, Arthur. We Are One Another, 2004, Amazon

Guirdham, Arther. The Lake And The Castle, Cynus Books.